Fundamentals of
Pastel Painting

A revised and enlarged edition of The Technique of Pastel Painting

Fundamentals of Pastel Painting

By Leonard Richmond and J. Littlejohns

WATSON-GUPTILL PUBLICATIONS, NEW YORK
PITMAN PUBLISHING, LONDON

First published 1970 in the United States and Canada by Watson-Guptill Publications,
a division of Billboard Publications, Inc.,
1515 Broadway, New York, N.Y. 10036

Published by special arrangement with Pitman Publishing Ltd., London,
whose *The Technique of Pastel Painting,* © Executors of the late Leonard
Richmond and Miss M. F. MacKinnon, 1966, furnished the basic text for this
volume.
ISBN 273-01274-6 Pbk.

Library of Congress Catalog Card Number: 70-98151
ISBN 0-8230-2051-7 Pbk.

Manufactured in U.S.A.

Paperback Edition
 First Printing, 1978

CONTENTS

LIST OF COLOR PLATES, 6

1. MATERIALS AND METHODS, 11
Pastels, 11
Choosing Colors, 12
Paper: Influence of Surface, 16
Paper: Influence of Color and Tone, 17
Laying-on, 20
Rubbing-in, 21
Preservation, 24
Sketching Materials, 25

2. STILL LIFE, 27
Working Indoors, 27
Composing a Still Life, 29

3. FLOWER STUDIES, 31
Begonias, 31
Daffodils, 34

4. PICTORIAL FLOWER GROUPS, 37
Marigold Leaves, 37
Marigold Petals, 40
Tulip Petals, 40
Tulip Leaves, 41
The Single Tulip, 41
Tulips in a Group, 43

5. LANDSCAPE: MATERIALS, 45
Sketching from Nature, 45
Sketching Papers, 47
Choice of Subject, 48

6. LANDSCAPE: TECHNIQUE, 115
Hills, 115
Clouds, 118
Trees and Water, 119
Seashore, 119
Mountains, 121

7. FIGURE, 125
The Portrait, 125
Figures in a Group, 133

8. ANIMALS IN LANDSCAPE, 135
Methods of Studying Animals, 135
Animals in a Group, 136

SUGGESTED READING, 141

INDEX, 142

LIST OF COLOR PLATES

PLATE I Influence of the surface of the paper, 49

PLATE II Influence of the paper upon pastels of opposed colors, 50

PLATE III Various methods of color blending and direct methods, 51

PLATE IV One-color demonstration (first stage), 52

PLATE V One-color demonstration (second stage), 52

PLATE VI Three-color demonstration, 52

PLATE VII Five-color demonstration, 52

PLATE VIII Use of two harmonious pastels (first stage), 52

PLATE IX Use of two harmonious pastels (second stage), 52

PLATE X Suggestiveness of pastel (first stage), 54

PLATE XI Suggestiveness of pastel (second stage), 54

PLATE XII Six examples of pastel painted over a prepared watercolor ground, 55

PLATE XIII Study of the texture of velvet, 56

PLATE XIV Study of the texture of shot silk, 57

PLATE XV First stage of preliminary charcoal sketch for *Cushions* (Plate XVII), 58

PLATE XVI Second stage of preliminary charcoal sketch for *Cushions* (Plate XVII), 58

PLATE XVII *Cushions*, 59

PLATE XVIII *A Black Jug* (first stage), 60

PLATE XIX *A Black Jug* (second stage), 61

PLATE XX First stage of preliminary drawing for *A Dutch Jug* (Plate XXIII), 62

PLATE XXI Second stage of preliminary drawing for *A Dutch Jug* (Plate XXIII), 62

PLATE XXII *A Dutch Jug* (first stage), 63

PLATE XXIII *A Dutch Jug* (second stage), 64

PLATE XXIV First stage of preliminary study for *The Statuette* (Plate XXVI), 65

PLATE XXV Second stage of preliminary study for *The Statuette* (Plate XXVI), 65

PLATE XXVI *The Statuette*, 66

PLATE XXVII Preparatory demonstrations for *Study of Begonias* (Plate XXVIII), 67

PLATE XXVIII *Study of Begonias*, 68

PLATE XXIX Preparatory demonstrations for *Study of Daffodils* (Plate XXX), 69

PLATE XXX *Study of Daffodils*, 71

PLATE XXXI Preparatory demonstrations for *A Group of Marigolds* (Plate XXXII), 71

PLATE XXXII *A Group of Marigolds,* 72

PLATE XXXIII Preparatory demonstrations for *Tulips in a Glass Jug* (Plate XXXIV), 73

PLATE XXXIV *Tulips in a Glass Jug,* 74

PLATE XXXV *Yellow Daisies,* 75

PLATE XXXVI *A Sussex Bridge* (first stage), 76

PLATE XXXVII *A Sussex Bridge* (second stage), 77

PLATE XXXVIII Preliminary note of construction for *Bolton Abbey* (Plate XL), 78

PLATE XXXIX Preliminary note of tones for *Bolton Abbey* (Plate XL), 78

PLATE XL *Bolton Abbey,* 79

PLATE XLI Preliminary note of construction for *Ben Venue* (Plate XLIII), 86

PLATE XLII Preliminary note of tones for *Ben Venue* (Plate XLIII), 86

PLATE XLIII *Ben Venue,* 87

PLATE XLIV *Autumn—Ely* (first stage), 82

PLATE XLV *Autumn—Ely* (second stage), 83

PLATE XLVI Preliminary note of construction for *The Trossachs* (Plate L), 84

PLATE XLVII Preliminary note of tones for *The Trossachs* (Plate L), 84

PLATE XLVIII A variation caused by light effects in the preliminary sketch for *The Trossachs* (Plate L), 85

PLATE XLIX *The Trossachs* (first stage), 86

PLATE L *The Trossachs* (second stage), 87

PLATE LI Line analysis of *The Quantock Hills, Somerset* (Plate LIV), 88

PLATE LII *Study for The Quantock Hills, Somerset* (Plate LIV), 88

PLATE LIII *The Quantock Hills, Somerset* (first stage), 89

PLATE LIV *The Quantock Hills, Somerset* (second stage), 90

PLATE LV Line analysis of *Study of Clouds* (Plate LVIII), 91

PLATE LVI Study for *Study of Clouds* (Plate LVIII), 91

PLATE LVII *Study of Clouds* (first stage), 92

PLATE LVIII *Study of Clouds* (second stage), 93

PLATE LIX Line analysis of *The Thames, near Maidenhead* (Plate LXII), 94

PLATE LX Study for *The Thames, near Maidenhead* (Plate LXII), 94

PLATE LXI *The Thames, near Maidenhead* (first stage), 95

PLATE LXII *The Thames, near Maidenhead* (second stage), 96

PLATE LXIII Line analysis of *Le Portal, Pas-de-Calais* (Plate LXV), 97

PLATE LXIV Study for *Le Portal, Pas-de-Calais* (Plate LXV), 97

PLATE LXV *Le Portal, Pas-de-Calais,* 98

PLATE LXVI Line analysis of *The Dolomites* (Plate LXVIII), 99

PLATE LXVII	Study for *The Dolomites* (Plate LXVIII), 99
PLATE LXVIII	*The Dolomites,* 100
PLATE LXIX	Line analysis of *Portrait of Mrs. T. R. Badger* (Plate LXXII), 101
PLATE LXX	Study for *Portrait of Mrs. T. R. Badger* (Plate LXXII), 101
PLATE LXXI	*Portrait of Mrs. T. R. Badger* (first stage), 102
PLATE LXXII	*Portrait of Mrs. T. R. Badger* (second stage), 103
PLATE LXXIII	Line analysis of *Market Day, Dieppe, France,* 104
PLATE LXXIV	Study for *Market Day, Dieppe, France,* 104
PLATE LXXV	*Market Day, Dieppe, France* (first stage), 105
PLATE LXXVI	*Market Day, Dieppe, France* (second stage), 106
PLATE LXXVII	*Study of a Cow* in black and white chalks on gray paper, 107
PLATE LXXVIII	*Study of a Cow* in pastel (first stage), 107
PLATE LXXIX	*Study of a Cow* in pastel (second stage), 108
PLATE LXXX	Study for *A Pastoral* (Plate LXXXI), 108
PLATE LXXXI	*A Pastoral,* 109
PLATE LXXXII	*A Group of Sheep* in halftone on gray paper, 110
PLATE LXXXIII	*Part of a Flock* in halftone on gray paper, 110
PLATE LXXXIV	*A Study of Sheep* (first stage), 111
PLATE LXXXV	*A Study of Sheep* (second stage), 111
PLATE LXXXVI	Study for *A South Downs Flock,* 112
PLATE LXXXVII	*A South Downs Flock,* 112

Fundamentals of Pastel Painting

1

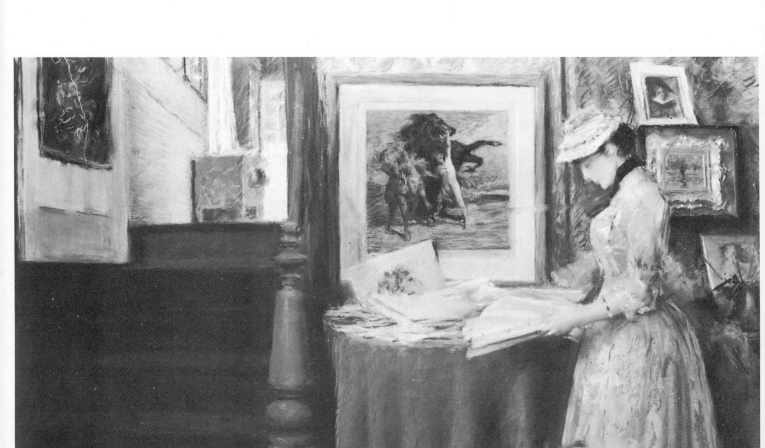

MATERIALS AND METHODS

Continual and varied experiments have made the authors less positive in their claims for the relative merits of certain technical methods. They now believe that they can be of more service to the serious student if they indicate no personal preferences, but give the results of their investigations into several methods without attempting to influence the reader's personal choice.

PASTELS

Pastels are composed of finely ground colored pigments and a little adhesive to hold the particles together. There are three grades—soft, semi-hard, and hard. Most pastellists use the first kind exclusively, or add a few of the others occasionally to obtain clearer definition, especially in portraiture. The range of available colors is ample for all purposes. Artists' pastels should not be confused with colored chalks. These are hard and rather brittle, intended mainly for the use of children in schools. The range is very small and the possibilities strictly limited.

It would be inadvisable, at this stage, to attempt to indicate the number of colors required because the selection, as will be seen later, must be influenced

INTERIOR by William M. Chase (1849-1916), pastel on paper. *Despite the elaborate subject matter, with its wealth of detail and intricate lighting, the artist has applied his chalk freely and has suggested far more finish and detail than are really there. The pattern on the dress fabric, for example, is simply indicated with the most casual strokes, which do not render so much as "indicate." The features of the face are merely touches of tone, while the hand is not so much delineated as simply suggested by patches of light and dark. The folds of the cloth on the table are divided into simple planes of light, halftone, and dark, which are softly blended together, with many of the strokes still showing. The handling of the architectural detail on the left is particularly interesting: none of the rectilinear architectural shapes are drawn with crisp edges and clean lines, but tend to have soft, ragged edges which blend into one another, creating a sense of space and atmosphere. (Joseph H. Hirshhorn Collection; photograph courtesy Davis Galleries, New York.)*

by the purpose and style of the drawing, as well as by the subject. Generally, it will be found that the nearer the approach to realism, the greater the number of colors required.

After a period of experiment, most artists reach a stage when certain combinations of color are found to be more personally expressive than others. The student should not attempt to hurry towards this stage without passing through the necessary experience. The final selection should not be the result of chance. These remarks apply most particularly to landscape; in painting still life, flowers, and portraits, the actual colors of materials may carry the artist over the whole range of color. It will be generally found, however, that a limitation of colors in any one picture to some restricted scheme is necessary for satisfactory pictorial effect; but as each picture may be in a different color scheme, the total number of pastels required for all pictures may be considerable. One of the fruits of experience is the power to make the most of a few colors.

CHOOSING COLORS

The actual choice of colors in the art supply store is made unnecessarily embarrassing by undescriptive fancy names given to most of the colors, and to the fact that a considerable number are practically duplicates. To those who wish their choice to cover the whole range, the following course is recommended until experience makes it unnecessary.

Make your own color charts: Paint, in oils, three color charts, as shown in the following diagrams. The *first* chart consists of twelve pure hues, covering the whole spectrum, with two tints and two shades of each, i.e., extended upwards by adding white and downwards by adding black. The *second* chart consists of the same hues modified by the addition of light and dark grays. The *third* chart consists of pure gray of various tones modified slightly by each hue. Together, these colors come surprisingly near to all the possible colors that can be required. If half the number are to be selected, choose the alternate hues and modifications, i.e., red, orange, yellow, green, blue, and violet. By so doing, the student will not only get a well-balanced selection; he will also realize the harmonic relations of each color to the whole range by studying these ordered arrangements.

CHART 1

Light tints												
Tints												
Hues	R	RO	O	OY	Y	YG	G	GB	B	BV	V	RV
Shades												
Dark shades												

Chart 1. First paint the middle row with the nearest possible approximations to the twelve pure hues. For the tints, add white until the tone is half-way between the hue and white. For the light tints, add white till the tone is half-way between the tint and white. Paint the shades on the same principle by adding black.

CHART 2

Lighter grayed hues												
Light grayed hues												
Grayed hues												
Dark grayed hues												
Darker grayed hues												

Chart 2. First paint the middle row with a mixture of middle gray with each hue so that the result is half-way between the hue and the gray. For the other rows, lighten or darken the grays on the same principle as in *Chart 1.*

CHART 3

Lighter gray						
Light gray						
Middle gray	R	O	Y	G	B	V
Dark gray						
Darker gray						

Chart 3. First mix five tones of gray as in *Chart 2.* Add a very small amount of each of the six hues and fill in the squares. This will give a graduated scale of 30 modified grays.

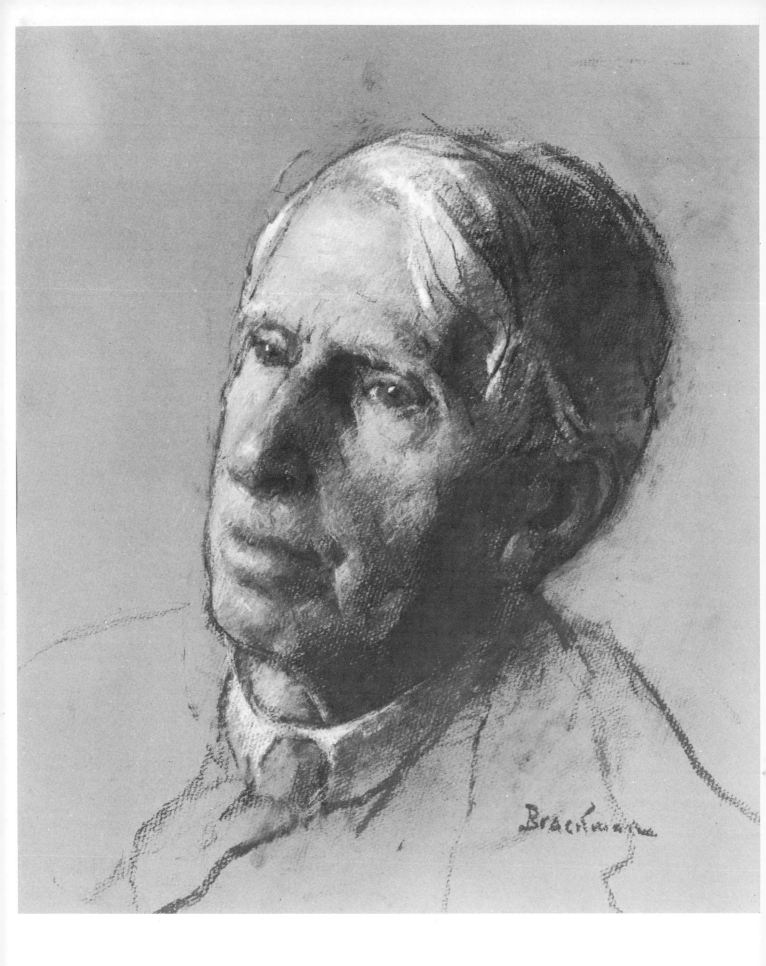

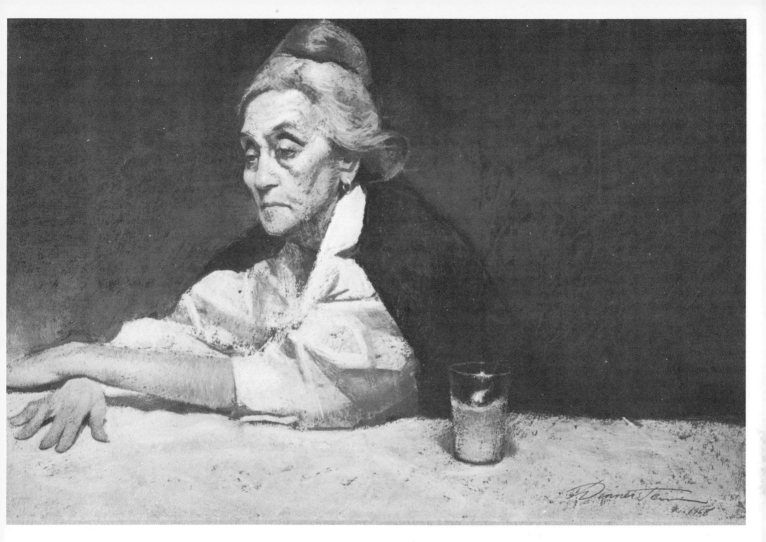

△

MEMORIAL CANDLE by Harvey Dinnerstein, pastel on board, 18″ x 29″. *To create his lively textures, the artist coats a 100% rag board with a mixture of ground pumice and gesso, which is applied to the painting surface with a brush or a palette knife. This creates a rich, uneven, unpredictable surface, which constantly strikes through and enlivens the strokes of the chalk. In many places, as the chalk moves over the brushmarks on the painted surface, the powdered color itself takes on the character of a brushstroke; this is particularly evident in the background of this painting and in the right-hand side of the table. Over this textured surface, the artist has built his tones from dark to light, as one can see in the face of the old woman. The strokes of the chalk are rarely smudged, but are built one over the other, developing a fascinating and intricate texture which becomes even more intricate as the textured surface breaks up the strokes. It is particularly interesting to see how a dark underlying tone constantly works through the lighter tone, as in the granular surface of the table and in the unexpected touches of darkness that appear in the sitter's light dress; thus, an effect of spontaneity is retained even when the painting is carried to a very finished state (Collection Mr. and Mrs. Martin Goldfield, photo courtesy Kenmore Galleries, Philadelphia.)*

◁LOUIS KRONBERG by Robert Brackman, pastel on paper. *Although every pastel painter is aware that his medium is ideal for rendering the delicate flesh tones of children, the medium is equally suitable for interpreting a weathered face like this one. The artist has relied on the rough surface of the paper—which strikes through the shadows in particular—and on short, irregular strokes, particularly in the light areas, to catch the unique character of his sitter's skin. Although such deep shadows along the brow, cheek, nose, and chin would not be suitable in a portrait of a child or a young person, they add character and drama in a portrait of a mature man. Observe how sparsely the back of the head is indicated and how little the artist draws of the collar or tie, merely suggesting the shoulders with a few carefully placed lines. (Photograph courtesy of the artist.)*

15

This, with white and black, brings the total up to 152 pastels covering the whole gamut of color in a perfectly ordered manner. Choosing from the much larger number of available pastels, 152 colors, as nearly as possible like those in these three charts, the beginner will find in this selection an exact likeness, or near approximation, to most colors he will need.

But no selection based upon a logical division of the whole gamut of color can be expected to satisfy special needs. The landscape painter will probably need more modifications of blue and green. The flower painter will find the selection weak in reds tinged with violet. These can be added as required.

Should any surprise be felt at the inclusion of so many grays, a few attempts to paint distances and clouds in a typical landscape will justify the number. The usual advice to the beginner is to first become acquainted with a few colors and add more as mastery develops. It sounds like wisdom, but the truth is in the opposite direction. Children naturally begin with a few colors because they do not need to get exact reproduction. But the serious older or adult student is dissatisfied with noticeable divergences, and he has not sufficient experience to be able to superimpose colors to get the others required. Besides, it often happens that the right color must be obtained in one direct stroke or not at all.

Usually, a small number of the colors will be needed in any one picture, but these should be as nearly as possible of the exact color required. And 150 or so short pieces of pastel, each about 1″ long, can be packed into a quite handy box. The landscape painter is then tolerably equipped for every kind of scene, every hour of the day, and every kind of effect. If, however, he always deliberately restricts himself to certain effects (if, for example, he never paints early morning light, or sunset glows, or autumn tints), he may pretty safely dispense with several of the warm colors. Experience, however, can best decide. But for still life, flowers, interiors, and figure subjects, the scope should be large and the colors well distributed.

PAPER: INFLUENCE OF SURFACE

The pastellist has at his disposal many suitable papers of varied surfaces. Providing that the pastel will adhere easily, almost any kind of surface, from fairly smooth to fairly rough, may be serviceable; but the same technical treatment cannot always be produced on different surfaces of paper. Only those who have

experimented sufficiently know to what extent the roughness, smoothness, hardness or softness of a paper can control the technical method to be successfully employed.

Texture: Take, for instance, a piece of coarse, hard paper, preferably pasted onto cardboard. Lay the pastel (about 1″ long) on its side and make a few strokes close together. The paper will then be covered with a collection of unevenly distributed dots of color surrounded by untouched paper. Press harder and the dots will enlarge and perhaps touch one another, leaving spots of paper between. On some papers the result will be a series of parallel lines of color, vaguely separated. Now treat a rather smooth and soft paper in the same way; the surface can be covered with less pressure and in no case will the dots be large.

Resiliency: Another less-known influence is that of resilience. When the paper is stretched over a stretcher frame, as if it were canvas, it "gives" pleasantly to pressure, and sometimes "takes" the pastel so as to produce an arrangement of dots differing considerably from what would happen if the same kind of paper were pasted onto cardboard. The adventurous mind naturally seizes on unexpected effects of the kind which can be turned to pictorial advantage, and is prepared to modify methods, and subjects if need be, in order to "cut the garment to fit the cloth."

Pastel papers: A warning must be given respecting a class of papers manufactured especially for painting in pastel. These papers have an alluring surface rather like velvet. They are delightful to use; but a few smart taps at the back may dislodge half the picture. The risk of total ruin is so great that these papers should never be used unless the whole picture is completely sprayed with fixative.

PAPER: INFLUENCE OF COLOR AND TONE

These are far more important than that of the character of the surface. If the whole surface is covered, so that not a particle of paper shows through, obviously, the color and tone of the paper does not matter. But if, as in most cases, a considerable proportion of the paper remains uncovered, the presence of thousands of tiny spots of paper of one color and tone among thousands of dots of pastel of another color and tone may change the whole color and tonal effect.

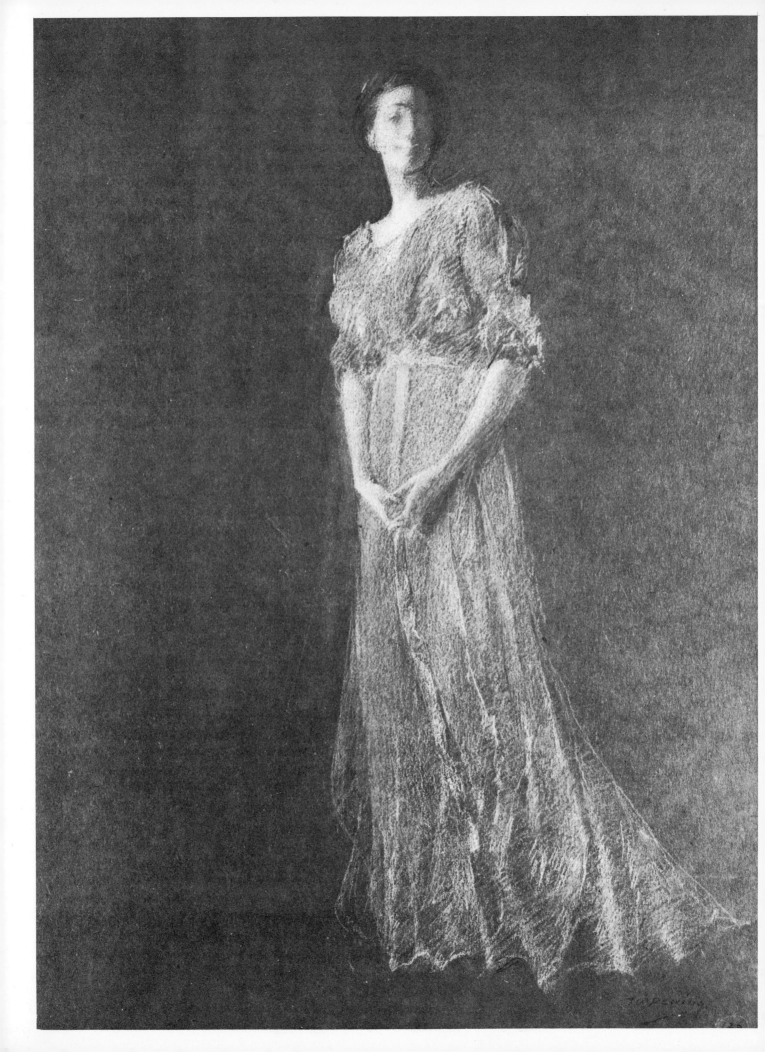

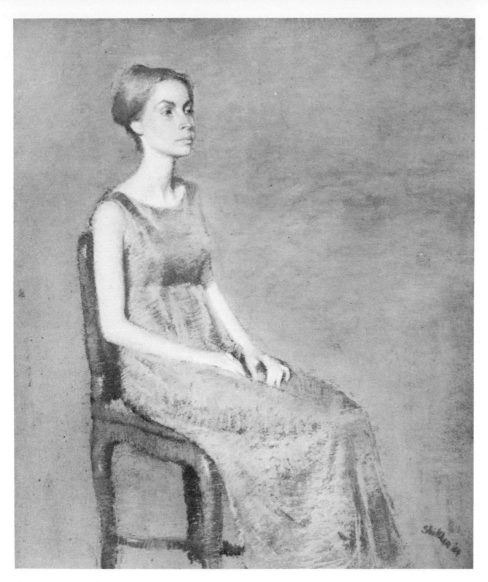

△

THE GREEN GOWN by Aaron Shikler, pastel on board, 15″ x 12⅞″. *The extreme delicacy of this figure is actually achieved by a very bold technique based on rough, ragged strokes that follow the shapes with an interesting combination of freedom and precision. The back and legs of the chair, for example, are rendered with short strokes that seem to wrap around the curve of the wood; each stroke is quite clear and individual, leaving a ragged but carefully drawn edge. The dress is painted even more boldly, with large, rough strokes broadly indicating the folds of light and shadow, each stroke standing out quite distinctly. Only in the head, neck, and arms do the strokes begin to melt into one another. The fingers melt together with only the slightest hint of shadowy breaks between them; the facial features are deftly placed touches of tone without hard edges. The background is extremely subtle, enlivened throughout by soft strokes which melt into one another, but are never concealed. (Photograph courtesy Davis Galleries, New York.)*

◁THE PINK DRESS by Thomas Dewing (1851-1938), pastel on paper, 13⅞″ x 10⅜″. *In this charming example of what the old masters called a* chiaroscuro *technique, the artist has methodically darkened his background with an intricate buildup of small, delicate strokes, then built up the lights over the background and an equally intricate pattern of small strokes of lighter chalks. There is practically no smudging or blending in the figure, but the chalks simply catch the tooth of the paper, and thus the texture of the paper shines through and animates every touch. The combination of small, flickering strokes of light chalk, and the texture of the paper constantly breaking through the strokes, gives an extraordinary effect of vibrant, delicate light which flickers across the page. Notice the selective finish, the drawing becoming more casual as the eye moves down the figure towards the skirt, which is left purposely "unfinished." (Photograph courtesy Davis Galleries, New York.)*

So great, indeed, are the possibilities that the pastellist has to be asking himself constantly: "What color shall I get if I press this particular pastel more or less heavily on the paper; for, unless I cover the paper completely, the color will not be exactly like the color of the pastel. How will it differ?"

For example, if a blue-green pastel were used on a pure red paper, with every possible variety of pressure, the result would be an infinite series of modified reds and blue-greens. Some parts, when seen at a little distance, would appear almost gray when surrounded with white paper. While brilliantly-colored papers are seldom used, because most of them fade, the considerable assortment of available safe grays and browns exercise a very powerful influence upon the choice of pastels and the way they are used. When the paper happens to be exactly similar to the color required, the pastel need not be applied at all; when the difference is small, a thin layer is sufficient; when the opposite color occurs, a great deal of pressure is required to modify the paper sufficiently.

Brown paper: Some of the problems which thus arise are illustrated in Plate II. Example D shows the influence of dark, warm brown paper when opposed to light blue pastel. With a fair amount of pressure, an effect of light, cool blue-gray is obtained, while light pressure, slightly rubbed in, gives the appearance of very warm gray.

Gray paper: This method of combining contrasting colors and tones gives a sense of brightness and energy. But when one pastel is overlaid with another, so that the paper is entirely covered, the top layer tends to merge into the one below, and the result is decidedly softer. In Plate I, example A, the combination of light gray pastel on dark gray paper is crisp and hard; in B, where the same light gray pastel is laid on a dark gray pastel, the merging results in an entirely different quality. Practical knowledge of facts of this kind (which give to pastel its distinctive character) sometimes determines the most suitable methods of technique, because the artist is then able to work in harmony with the fundamental characteristics of the material.

LAYING-ON

The influence of the paper is further extended by different ways in which the pastel can be laid on: (1) by using the point and making a series of lines with spaces between; (2) by covering the paper evenly, using either the side of the pastel, or lines with the point close together; (3) by making separate dots like the pointillism of the early Impressionist painters.

The extent to which these three ways of handling, on various paper, can influence the treatment and even the choice of a subject, cannot be fully appreciated without practical experience. It will then be found that: (1) the use of lines tends to strengthen the expression of form, (2) ease in expressing flat surfaces tends to emphasize the value of broad effects and quiet tones, (3) pointillism is unsuited to the expression of hard edges and long thin lines, but is an unrivalled method for the expression of vibration.

RUBBING-IN

One often hears, from narrow-minded and inexperienced enthusiasts, a thoroughgoing condemnation of the method that is known as "rubbing-in." To smear a little pastel over the paper and rub it with the finger is regarded as a feeble way to treat the material, and as a sign of incompetence. And so it often is—but not always. This contemptuous attitude towards a method employed with brilliant success by some of the finest pastellists has been created by the failures of those who attempt to gain certain effects in this way which could be better secured by other ways.

There can be no reasonable objection to rubbing-in or to any other method when it is successful, and there is no sense in decrying any means because the end is not justified by the inefficient. Rubbing-in need not result in ineffectual softness; in fact, it may contribute to an enhancement of brilliance by forming a delicate background for strongly marked, direct strokes. In short, rubbing-in, like most other methods, can be used for good or for ill, with knowledge and discretion or with ignorance and indiscretion.

In pictures where the artist is dealing with large surfaces, almost any form or texture may be expressed by direct strokes, but in many small pictures this is impossible. And there are many cases where the same breadth or delicacy cannot be obtained in any other way. Rubbing-in the whole of the first stage of a pastel amounts to varying the even tone and color of the paper so that fewer and more effective direct strokes are required. Most of the failures of the rubbing-in method can be explained by one or the other of two reasons. The majority are evidences of incapacity; the others are generally attempts to make a pastel look as if it were done in some other medium, such as watercolor or oils. But if it works—if, that is to say, it is expressive and honest, revealing beauty and not attempting to be what it is not—all theoretical objections are baseless.

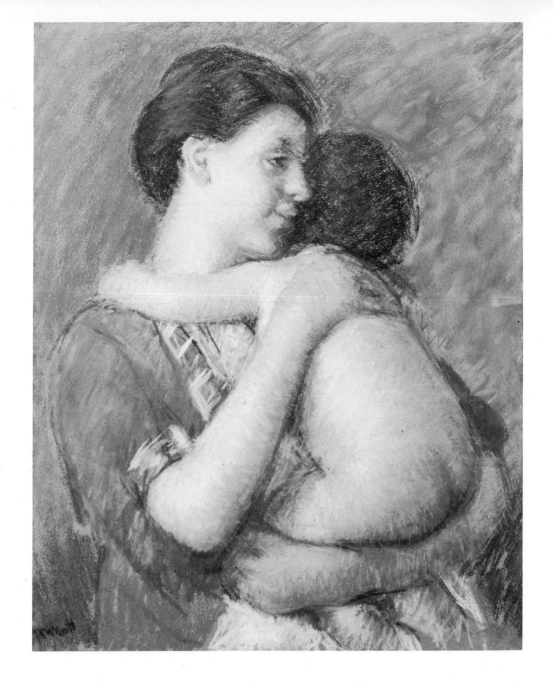

MOTHER AND CHILD by Mary Cassatt (1845-1926), pastel on paper. *In painting something as delicate as a child's skin or the skin of a young mother, it is tempting for the beginning pastellist to rub his flesh tones until they begin to resemble the bloom of a peach. Yet the effect is often far from what he wants and is more likely to resemble lifeless pastel dust. In this painting, the artist has done exactly the opposite, relying upon vibrant, scribbly strokes which follow the form around, moving from halftone to light to halftone and communicating remarkable luminosity—precisely because the strokes crisscross and interlock to give the effect of delicate, shimmering light. The forms are almost entirely devoid of detail: the hands barely have fingers, the clothing barely has folds, and the hair is simply a patch of broken color. Only the mother's face has any hint of detail in the features, although these are rendered as casually as possible. Yet the forms have great solidity because the artist has carefully studied the transitions of light and shade on the rounded shapes. It is this careful observation that allows the artist to apply her strokes so freely. (Metropolitan Museum of Art, New York.)*

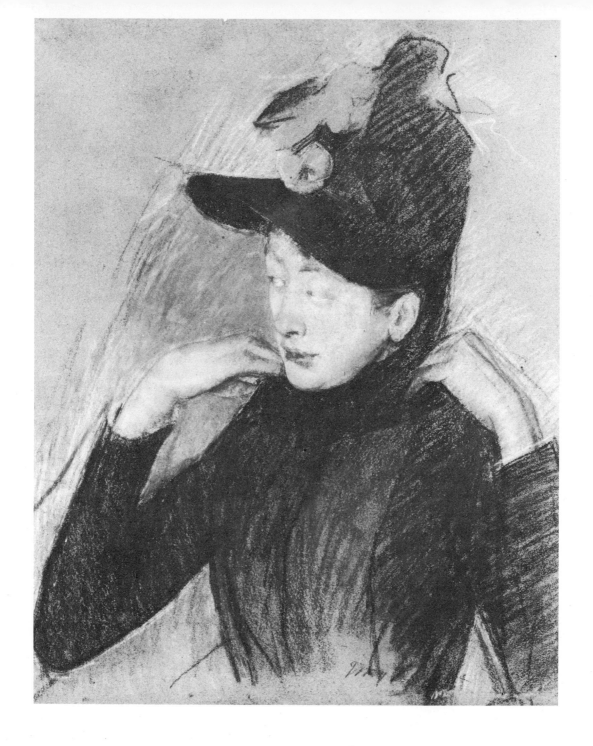

THE BLACK HAT by Mary Cassatt (1845-1926), pastel on paper. *What is most interesting here is the calculated lack of finish in most of the painting. Although the face and hands are carefully modeled, the clothing is simply a flat shape defined by strong edges and filled with broad, diagonal strokes. The flowers on the hat are simply spaces of bare paper with a few touches of color. The background is almost entirely bare paper except for the tone beside the cheek—necessary to indicate the shape of the cheek—and the strokes of light around the hat and left hand. The effect of this unfinished quality in most of the picture is to focus the viewer's attention primarily on the head and hands, with the shapes of the clothing simply providing a frame. The viewer's inclination is always to focus on the most finished parts of the picture. (Philadelphia Museum of Art.)*

Art patrons frequently hesitate to purchase pastels because of the fragility of the medium. Occasionally, when the picture is severely shaken, a little of the pigment falls onto the lower edge of the mat or inside the frame and arouses the fear that the whole of the picture may disappear from the paper! All objections arising from this cause, however illusory, would be removed if pastels could be securely fixed (that is, sprayed with fixative) without other injuries. Unfortunately, there seems to be no completely satisfactory method of fixing.

Spray fixative: Consider what fixing means. When the fixative is sprayed over the pastel, each particle becomes partly or wholly covered with a very thin film of adhesive substance so that each particle will stick to others and to the paper. Three deleterious consequences are almost certain to follow: (1) some of the particles will be blown or washed off in the spraying; (2) some will change color; (3) most of them will be pressed closer together with less spaces between. So the difference in the appearance of an unfixed and a fixed pastel is something like that of dust and caked mud. And with this change goes much of the expression of spontaneity which is one of its most distinguishing charms.

Matting: Pastel *can* be fixed but, speaking aesthetically, the cost is too great. Better, by far, to concentrate upon other methods of preservation. When it is matted and framed in the same way as a watercolor, the mat should be very thick so that there will be no risk that the pastel will touch the glass. A few light taps with a fingernail against the back of the paper before matting will remove the very loose particles. This should cause no observable difference in appearance. If it does, either an unsuitable paper has been used or the pastel has been laid on too thickly.

Framing and hanging: The paper on which larger pictures, such as portraits, are painted if they are to be framed in the same way as oils, should be stretched on a canvas stretcher frame or pasted on to stiff cardboard. There should always be a backing of wood sealed at the edges. The picture should never be hung on a damp wall. Should the state of the wall be doubtful, two pieces of cork, attached to the lower edge of the frame where it would otherwise touch the wall, will absorb slight moisture.

Pastels are more permanent than watercolors and oils. There are fewer non-permanent colors among pastels than is the case with oil paints, because none is affected by combination or darkened by admixture with oil; and they will maintain their original purity of color for hundreds of years.

SKETCHING
MATERIALS

The materials required for outdoor sketching are light and easily carried. A camp stool, two boxes of pastel, about six sheets of tinted paper clipped onto a sheet of wallboard (such as Masonite), and a cloth for protection, can all be put in a rainproof bag with a handle attached. An extra camp stool (very light in weight) is sometimes useful as the pastel boxes can be placed on it and thus be ready for use near the hand of the artist.

The simple color demonstrations shown in this book should convey some of the possibilities of pastel as a medium for outdoor sketching, but the beginner in landscape is often confused by the inexhaustible quantity of detail seen in nature. This difficulty can be remedied if a miniature sketch is made of the leading lines and masses in one or two colors before commencing the larger subject. Plate VII gives an indication of a workman-like sketch that illustrates the compositional aspect of the subject. One can afford to make a few mistakes in the general pattern of the larger sketch, providing a correct note has previously been made of the original subject.

No one can deny the many advantages arising from the use of pastel for outdoor sketching. As regards rapidity, this medium can be handled infinitely quicker than any other—and speed is of paramount importance to the keen observer of passing effects in nature. The value of pastel becomes quite obvious when sketching quickly-moving clouds. On a sheet of dark gray paper, it is possible to make a cloud study in a few minutes. The neutral tint of the dark paper helps to harmonize contrasting colors. The characteristic use of pastel suggests drawing combined with mass color formations. On another occasion, it may be necessary to sketch a flashing effect of sunlight seen on buildings, trees, etc. On a warm gray paper, touches of orange and light yellow ochre can be judiciously placed in more or less correct positions on the tinted paper, and the pastel drawing of the shadows and various accessories can be finished later.

2

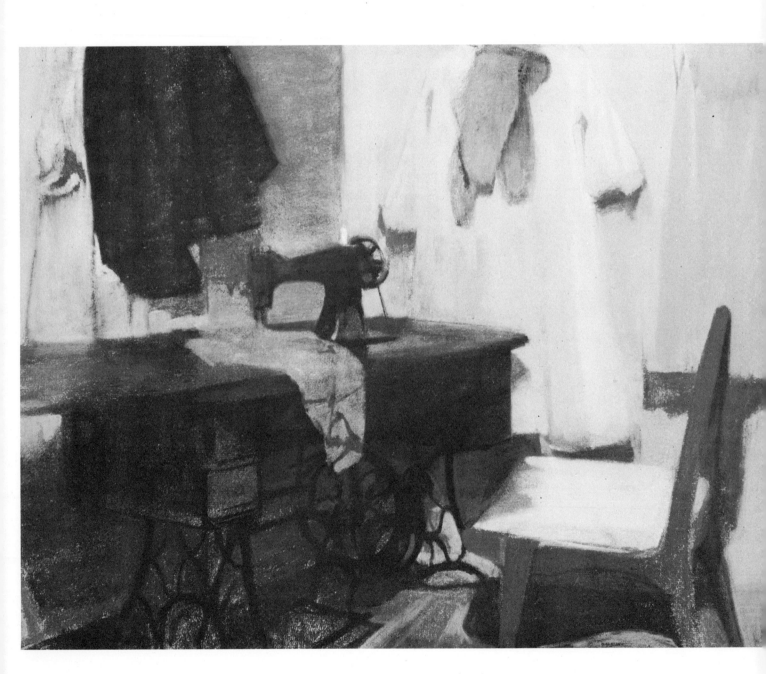

STILL LIFE

There is everything to be said in favor of commencing the study of the technique of pastel with still life, when pursued systematically. It is not suggested, however, that it would be desirable to perfect the handling of the medium by means of simple exercises before proceeding to the more pictorial aspects. The constructive and creative ends should not be neglected by over-concentration on the technical means. That kind of study can be disastrous and is never beneficial. At the same time, still life can be used as a means of discovering and tackling certain technical problems which had better be solved early in the course of study.

WORKING INDOORS

The student sitting calmly indoors contemplating simple forms, colors, and textures, can give much attention to technique without neglecting the aesthetic purpose. But outdoors, the student is beset by so many other difficulties that he cannot afford to complicate the problem by experimenting with elementary forms of technique.

Indoors, he can choose subjects suited to his capacity and stage of progress. He can study one technical problem at a time, and make the course progressive

THE SEWING ROOM by St. Julian Fishburne, pastel on paper, 16¾" x 20 ¾". *It is very important for the student pastellist to learn to see in terms of flat tonal areas, as this artist has done. The sewing machine and the chair in the foreground are essentially flat planes of tone, as are the shapes of the walls and the clothing hanging in the background. Having first recorded these flat shapes, the artist has then gone back into them and overlaid decisive strokes which pick out the intricate ironwork of the sewing machine, a few folds on the hanging clothing, an edge of shadow or a flicker of light. The texture of the paper is always present in a pastel painting, and the artist has allowed this texture to shine through in the lower left foreground, for instance, where his strokes do not quite cover the paper, which breaks through in tiny points of light, adding vibrancy to the shadow tones. (Photograph courtesy Davis Galleries, New York.)*

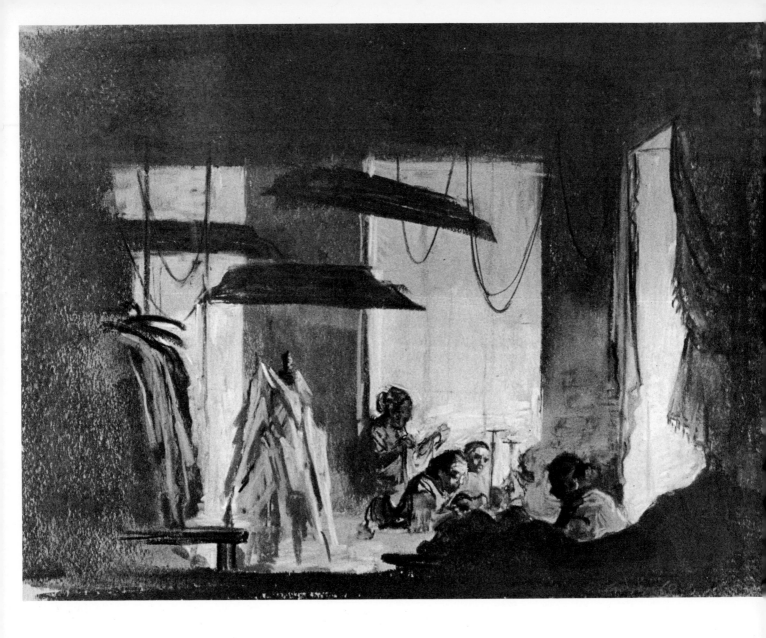

DRESSMAKERS by David Levine, pastel on paper, 14″ x 19″. *Pastel combines the speed and directness of drawing with the tonal and color range of painting. In this interior with figures, the artist has caught a complex effect of light and shade with great speed and economy of means. The figures and the lighted windows are framed in broad patches of tone which render walls, ceiling, and foreground quite abstractly, and almost totally without any indication of detail. The hanging light fixtures, too, are simply patches of tone, rendered in long strokes which follow the direction of the shape. Only the figures, themselves, carry any indication of detail; but these details are merely patches of tone for shadows in the eye sockets, under noses, under lips, etc. The folds of their clothing and of the clothing on the racks are simply rendered in broad strokes of light and shadow, with no attempt at precise rendering. It is worthwhile to study how the clothing at the extreme left melts into the shadows, just as the back of the standing woman melts into the shadow of the wall. The face of the woman to the right has been darkened and the background lightened in order to throw her into dramatic silhouette. (Photograph courtesy Davis Galleries, New York.)*

and, at the same time, he can develop his powers of pictorial arrangement and expression. But he should not regard still life as necessarily elementary and preliminary to the study of more important subjects.

There is no limit to the technical possibilities or opportunity for the expression of a sense of form, color, design, and a high order of imagination. Still life naturally extends to interiors which may be far from elementary. It is also an invaluable study for dress and accessories in portraiture and other figure subjects. After a few preliminary exercises, designed to cultivate a little freedom in handling, every object or group of objects should be arranged as a fitting subject for a picture and not as a mere study in technical methods. A single object, well placed, effectively lit, and harmoniously related in tone and color with its background, can be sufficient material for a thing of exquisite beauty.

COMPOSING
A STILL LIFE

Readers will notice a similarity in the basic arrangement of the three still lifes in Plates XIX, XXIII, and XXVI. In each, there is an important feature, almost in the center, standing on a flat surface with subsidiary features grouped around its base. This has been done deliberately in order to suggest the possibilities of different effects with one form of composition. The most striking differences are obtained by variety of shapes, tones, colors, lighting, and backgrounds.

A Black Jug (Plate XIX) is the simplest arrangement. The jug is in striking tonal contrast with the rest, while modified by a considerable amount of gray. There is a great variety of surface expressed.

A Dutch Jug (Plate XXIII) introduces a new variation consisting of the upright lines of the curtains and reflections contrasting with the curvature of the jug and the apples. Lit from the back, the objects are mostly in shadow.

These are a few of the ways in which a similarity in the basis of arrangement can be varied almost beyond recognition.

The Statuette (Plate XXVI) relies for effect upon rhythmic lines emphasized by the lighting on the edges of all the features, and by the concentration of color on an otherwise subsidiary feature—the green beads—which becomes a center of radiating lines.

3

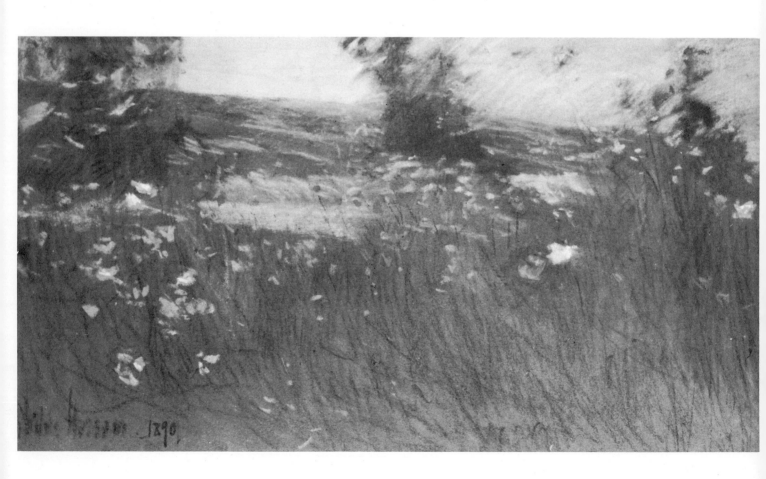

FLOWER STUDIES

As a medium, pastel is peculiarly adaptable for the rendering of flowers. The brilliancy of coloring generally associated with flowers is not so easy to get in water or oil colors. The dilution of water tends to weaken the original brilliant tint in watercolor pictures, and in oil painting it is hardly possible to use any color without a mixture of white paint. This, with the darkening qualities of oil already mixed with the color pigment before being packed in the tubes, causes considerable deterioration of the original color. While it is true that some of the brightest pastel tints are not permanent, yet it is equally true that the majority are quite safe.

For flower painting, a large range of brilliant colors should be selected, including a gradated series of lemon yellow, chrome, rose purple, vermilion, crimson, and bright green. To support the brighter tints, the usual assortment of ordinary, but very useful, colors such as yellow ochre, light red, gray, blue, etc., should always be ready for use.

BEGONIAS

The various examples of pastel handling in the preparatory demonstrations in Plate XXVII for *Study of Begonias* give enough information as to the best method for painting scarlet begonias. The two demonstrations at the top left side indicate the possibilities of getting more than one tint with one stick of pastel. The solid patch of crimson is echoed immediately below by a darker shade of the same color. The darker shade is obtained by pressing lightly on the

POPPIES, ISLES OF SHOALS by Childe Hassam (1859-1935), pastel on paper. *The foreground is dominated by the underlying tone of the paper, which is crossed by delicate strokes that indicate the high grass and weeds in the field. The poppies are picked out with quick, dashing strokes of chalk that make no attempt to shape the flowers, but are simply notes of color. In the middle distance, the strokes merge into soft masses of color surrounded by flecks of color for individual flowers. The trees that break across the horizon are blurs of color with light sky tones between them. The method is essentially a light on dark technique. (Collection Mr. and Mrs. Raymond J. Horowitz.)*

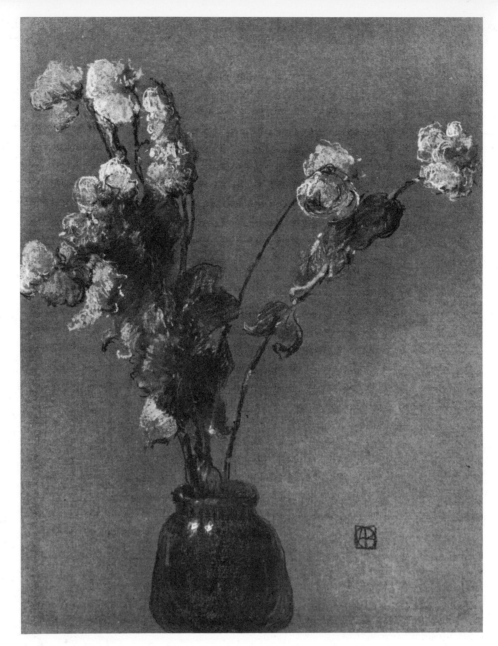

FLOWERS IN A BLUE VASE by Leon Dabo (1868-1960), pastel on brown paper, 15½" x 12". *The artist has used his paper most effectively as a middle tone, darker than the flowers themselves, but lighter than the stems, leaves, and jug. At certain critical points, he has darkened the paper ever so slightly—behind the bloom on the right, for example —in order to make the light notes more luminous by contrast. Observe how the strokes follow the shape and gesture of the subject; the strokes trace the roundness of the jug, the rippling quality of the flowers, and the curling shapes of the leaves. Knowing that the greatest danger in pastel painting is to go too far, the artist has wisely left his background bare except for touches of slightly darker tone behind the flowers. The paper, itself, is often the best background. (Photograph courtesy Davis Galleries, New York.)*

ROCHELLE AT BREAKFAST by Robert Philipp. *The artist has applied his chalks roughly,▷ building up a pattern of scribbly strokes which he rarely blends, but lays one over the other to give a vibrant texture to the entire painting. The only obvious blending is in the face and arms, where subtle modeling was needed. The background is simply scribbled in with patches of flat color, and the tableware in the foreground is barely sketched in—more drawn than painted. The dress is a particularly successful example of how a pattern of strokes can create the texture and weight of fabric without rendering the folds precisely, simply relying on the direction and the weight of the strokes. Much of the charm of the painting is in its casual, unfinished quality, typical of many of the best pastels. (Photograph courtesy Grand Central Art Galleries, New York.)*

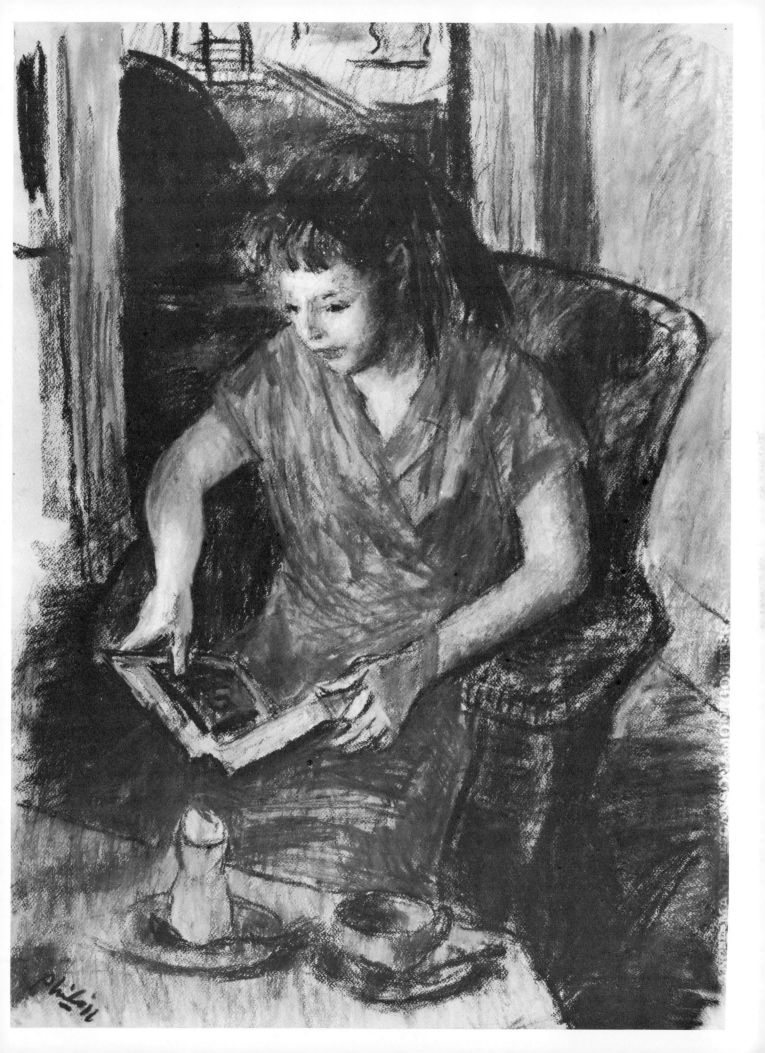

dark gray paper. The orange chrome pastel was treated in precisely the same way as the crimson pastel. These two little exercises of pastel pressure prepare the way for the other demonstrations recorded in this reproduction. The foundation of good flower painting in pastel is to successfully suggest light and shadow with one color only. Notice how crimson in the reproduction has achieved this desirable result. The centers of the flowers were painted with yellow-green, and the crimson petals radiate outwards from the center of the flower.

In the larger example at the lower end on the right, the crimson petals were reinforced with touches of orange chrome. The introduction of this color immediately gives intensity to each petal through the effect of vivid light, while contrast makes the shadows appear deeper in tone.

It is very important to remember that all pastel lines should be rendered with the utmost decision combined with a brisk, sparkling effect. Any timidity in handling—especially in the first stage of flower painting—invariably affects the final touches.

Ordinary green followed by touches of light gray was adopted for the leaves, seen in *Study of Begonias* (Plate XXVIII), and treated in the same manner as advocated for the leaves in Plate XXVII. This finished study of begonias retains the same characteristic handling of pastel, showing the crimson and orange chrome lines radiating outwards from the center of each flower as illustrated in the previous reproduction. Bright purple was also used for deepening the shadows. This color is admirable when blended with crimson on a dark gray background, since it does not take away any purity of color so essential to good flower painting. When black, dark brown, or charcoal, is mixed with crimson, the latter color becomes opaque and less pure in tint. The dark tone of the background immediately behind the leaves and flowers was done with a deep shade of burnt umber pastel.

DAFFODILS

Plate XXIX represents detailed pastel drawings of daffodils. To draw these flowers is not difficult for the average artist, but the coloring is nothing like so easy. The petals of the flower have a suggestion of delicate green intermingled with the lemon yellow tint. This vague atmosphere of green has been incorporated with yellow in this plate by placing in the first instance a thin layer of light Hooker's green directly on the tinted paper (see the example at the top right-hand side). The two petals immediately below show the result of using lemon yellow on the prepared light green ground. In the highest lights the

lemon yellow was pressed very heavily on the paper so as to partly obliterate the light green and also to give solid highlights. In the petal shadows the evidence of green is more noticeable.

The two petals on the top left side were done directly on the paper without any foundation of green. For green paper, the result would probably have been correct and similar to the yellow petals on the right. Orange yellow was used for the main or shaft portion of the flower, heightened with one or two touches of lemon yellow, as seen in the drawing of the whole flower centrally placed on the left side. It is better to err on the side of bold handling when painting daffodils with pastel. A slavish copy of the original flower is apt to look lifeless in the finished picture.

The circular color demonstration on the left at the foot of the reproduction was made with orange yellow. It was originally rendered with a rough texture like the example immediately above, but the color was smoothed into a flat all-over tint by rubbing in the pastel with the fingers. The light fringed border was made by pressing strongly with the same pastel and was strengthened with a touch or two of lemon yellow.

The charcoal drawing shows the construction of the main portion of the flower. The lemon yellow line examples placed below the charcoal drawing are a reminder of the importance of practicing converging pastel curves, since so many flowers can be commenced in this manner.

All the daffodils in *Study of Daffodils* (Plate XXX) were treated by the same method as already described. A little yellow and light green pastel was worked into the paper between some of the flowers and leaves so as to soften the edges in places, and to prevent the group from becoming too assertive at the expense of unity.

The leaves call for little comment, but the junction of the upper part of the stalk to the flower required careful drawing and discreet color. The reproduction shows clearly the color used for this purpose.

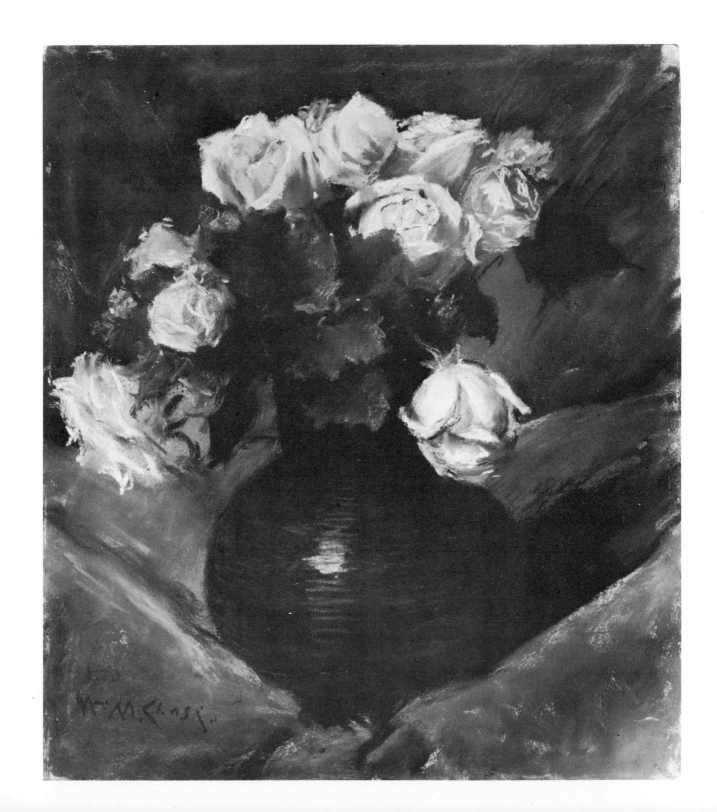

PICTORIAL FLOWER GROUPS

Plate XXXI shows various color demonstrations as a preparatory exercise in the technique of pastel before a similar subject is attempted in *A Group of Marigolds* (Plate XXXII).

MARIGOLD
LEAVES

The two leaves at the top on the left side of Plate XXXI are drawn in two stages. The first example was previously drawn in charcoal on the dark gray paper before any color was added. Only one color was used, namely green. This pastel, being considerably lighter in tone than the dark gray paper, required delicate handling in the suggestion of the shadow portion of the leaf. This is entirely a matter of varying degrees of pressure, and considerable practice is necessary to acquire enough skill to avoid difficulties when rendering light and shadow. It is, of course, much easier to suggest the lighter-colored portion of the leaf than the shadow section, but even then care has to be taken, otherwise the lighter tint is liable—through over-pressure—to become opaque, or heavy, in which instance the luminosity of the shadows would lose some of its value.

Dark green was added to the shadows in the final touches, thus giving solidity to the leaf, and touches of light, silver gray were used where required on top of the light green so as to intensify the effect of contrast, while helping to achieve a more correct rendering of a naturalistic study.

ROSES by William M. Chase (1849-1916), pastel on paper. *The lush shapes of the flowers emerge from a dim background, with the leaves in shadow or in silhouette and the vase itself simply a dark shape with a highlight. Everything is subdued to the crisp, spontaneous strokes used to paint the flowers; the folds of the foreground drapery are sparsely indicated and the background drapery is simply a varying dark tone which provides a contrast to the lightstruck flowers. Notice how the petals of the roses are not rendered individually, but simply by strokes of the chalk. (Collection Mr. and Mrs. Raymond J. Horowitz.)*

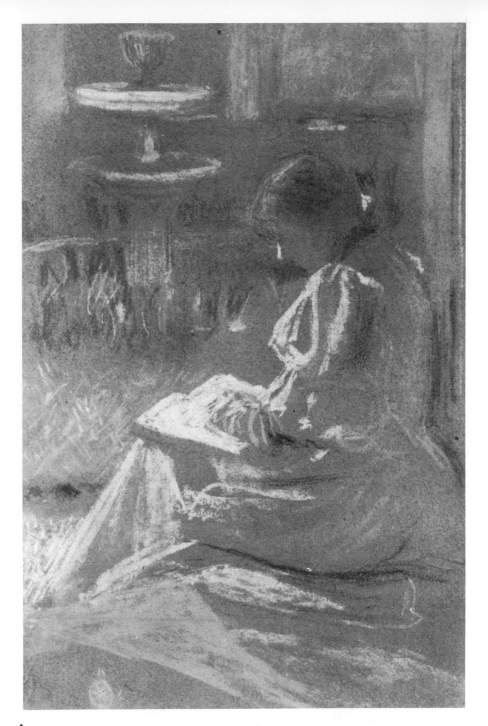

△
WOMAN READING BY FOUNTAIN by Albert Sterner (1863-1946), pastel on paper, 16¼″ x 10½″. *The dominant tone is that of the paper, which provides the middle value against which a very limited number of other tones are placed. Lighter strokes are carefully positioned to indicate the folds of the dress, the book, and the fountain, in which the color of the paper provides the halftone. A few darks are then carefully placed beneath the figure, to her right, on her arm, and on her head. Thus, the combination of paper, light strokes, and dark strokes gives a complete tonal range with a minimum of effort. (Photograph courtesy Ira Spanierman, Inc., New York.)*

BACK OF A NUDE by William M. Chase (1849-1916), pastel on paper. *The extremely ▷ delicate, pearly tone of the skin has been lightly blended with the fingertip, but the strokes have not been completely obliterated. Notice the light diagonal strokes that appear very faintly across the lower back and over the arms. The artist has carefully avoided sharp edges by softly blending the edges of the arms into the surrounding colors and has drawn no sharp lines to isolate the figure, thus maintaining an extremely subtle surface unity throughout the picture. (Collection Mr. and Mrs. Raymond J. Horowitz.)*

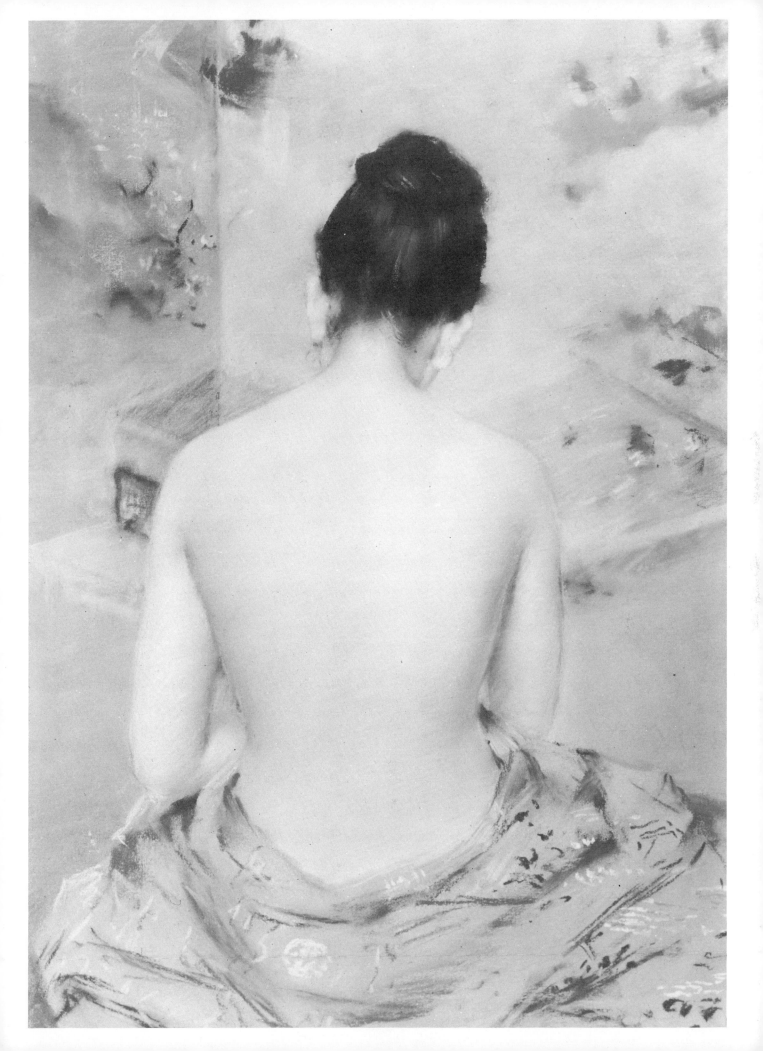

The two leaves on the right were treated in precisely the same way with the same colors as the others on the left side. The leaf curving over at the top gives some additional interest from a drawing standpoint.

MARIGOLD
PETALS

The three separate parallel petals in the second line of demonstrations in Plate XXXI immediately below the leaf studies are very important to the potential painter of flowers, since they constitute the foundation on which the flower is built. Commencing from the left, the first petal shows a flat tone of burnt sienna. The second example represents the same burnt sienna petal with touches of orange chrome. Notice how much more lively the petal looks under the influence of orange chrome. The third drawing on the right is finished by adding two or three touches of lemon yellow, but only on top of portions of the orange chrome. Lemon yellow represents the highlights, orange chrome the halftone, and burnt sienna the shadow. In the same line, the example placed on the extreme left side shows the effect of the knowledge gained by the mastery of the petals in three stages. The treatment is precisely the same and therefore calls for no special comment.

At the foot of the reproduction are several examples of lightly-handled pastel displaying harmonious lines. Three are rendered with lemon yellow only. The other two were made with orange chrome, and lemon yellow with orange chrome, respectively. This method of line treatment is earnestly advocated as a means of gaining a decisive style in pastel handling. It is very helpful in laying the first stage of flower groups or single flowers.

Looking at *A Group of Marigolds* (Plate XXXII), one will readily see that there are no secrets to unearth after the information already given as to the best methods for painting marigolds. The decoration suggested in the background gives it some variety, and the light yellow ground material in front displays a lively movement which affords a strong contrast with the quiet solidity of the earthenware bowl.

TULIP
PETALS

The numerous color demonstrations in Plate XXXIII are all of equal importance to the potential painter of tulips. The vertical row of five colors gives

the necessary range of tints for rendering a complete study of a tulip petal. Commencing from the top, these colors are: deep orange, crimson, orange chrome, chrome yellow, and light violet.

The tulip petal is shown in four stages. The first demonstration, commencing at the top line on the left, was lightly drawn in charcoal followed by a series of deep orange lines, drawn in the same upward direction as the petal. In the second demonstration, crimson pastel was intermixed with the deep orange on the left, while orange chrome was used on the right and also at the lower part of the same petal. Similar treatment was adopted for the third example with the addition of a few sharp lines of chrome yellow which connect the edging of orange chrome towards the central portion of the petal.

The whole of the tulip petal in the final stage shows better drawing and more stylistic handling. The light is more diffused as the result of adding a few adroit touches of light violet pastel. The same color also assisted in getting an atmosphere of bloom on the surface of the petal similar to the peculiar bloom associated with garden or orchard plums.

TULIP LEAVES

The feeling of converging lines is very noticeable in the finished pastel study, *Tulips in a Glass Jug* (Plate XXXIV). The vigorous formation—or stucture—of tulips demands a stringent style of pastel handling. To use solid layers of pastel for these gay-looking flowers is courting disaster from the start. It is only in the final touches that opaque treatment can be used with safety. The study of a tulip leaf in two stages follows the four petal demonstrations in Plate XXXIII. Four colors were used: namely dark green, medium green, light gray, and lemon yellow. These colors are placed horizontally immediately below the leaves. The first stage shows a definite contrast in light and shadow through the use of light and dark green, but in the second and final drawing the light on the leaf is greatly intensified by light gray and a little lemon yellow.

THE SINGLE TULIP

The tulip demonstrations in Plate XXXIII represent three stages. The first was drawn in charcoal, and delicately tinted with reddish purple. For the second stage, crimson and yellow ochre were introduced, care being taken that the

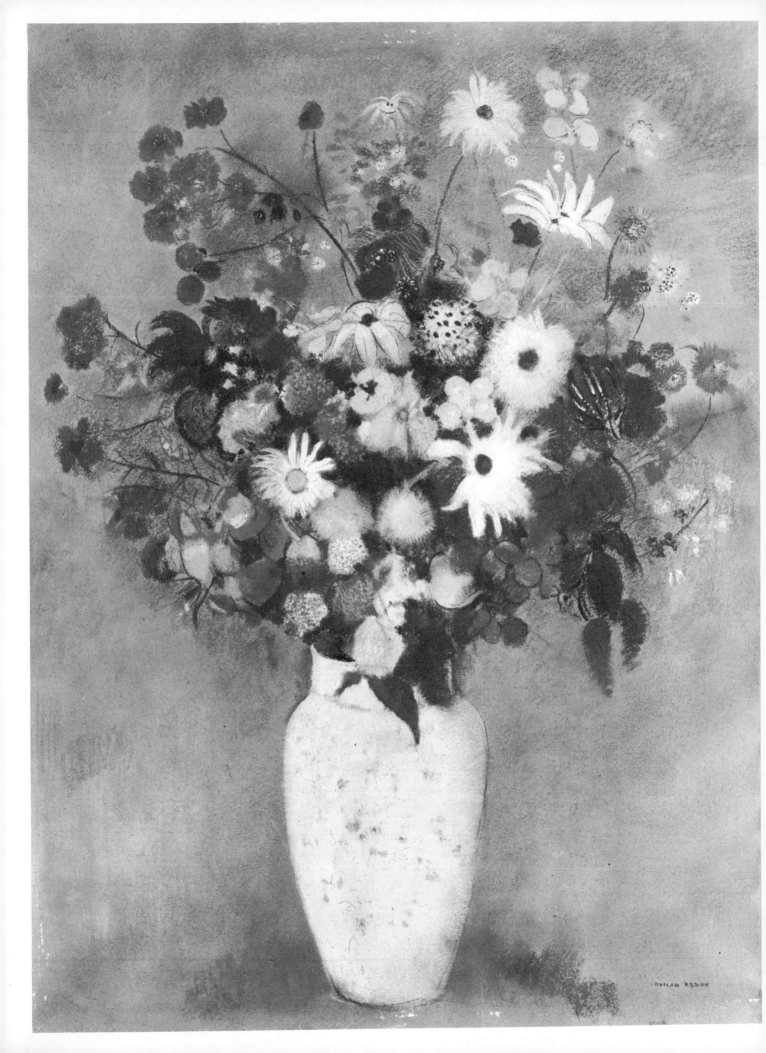

pastel strokes, or lines, were drawn in the same direction as the petals. White was added for the final stage, and also a little reddish purple so as to give some variety to the crimson portion of the flower on the left side.

The four colors used—namely reddish purple, crimson, yellow ochre, and white—can be seen in a horizontal row at the lowest end of the reproductions.

TULIPS
IN A GROUP

The groups of tulips seen in *Tulips in a Glass Jug* (Plate XXXIV) were done while the flowers were still freshly gathered. It is a mistake to linger over each flower when a group of flowers has to be rendered in pastel or any other medium. The general effect of the whole group must be kept in mind, otherwise there is a danger of rendering unimportant detail at the expense of the main subject.

Plenty of knowledge relating to the construction and color of the flowers and leaves is vastly important in painting any group of flowers. No difficulties in technique must handicap the artist if success is to be obtained. The mastery over technique leaves the artistic mind free to function naturally. The true technician is unaware of technique when under the influence of the pleasurable excitement of painting pictures.

No detail has been shown in the background behind the flowers, so that each tulip is free from any unpleasant opposition from that source. Likewise, the top of the amber jug was simplified so that the lower tulips could have the same privilege. The chief colors used for the painting of the glass jug are dark gray, orange chrome, a little dark purple, green, and white. The colors for the handle are dark and light blue, gray, a little emerald green, and white. The foreground was made with light yellow ochre, reddish purple, blue, and gray. These tints were rendered with considerable freedom, which helps to give an animated pastel surface, thus affording marked contrast with the spacious background.

VASE OF FLOWERS by Odilon Redon (1840-1916), pastel on paper, 28¾" x 21⅛". *In painting this luxurious bouquet, the artist wisely surrounded the subject with the simplest possible background. The flat tone of the paper has been delicately animated with a variety of soft strokes, creating a faintly irregular tone in combination with the tone of the painting surface. This background tone darkens or lightens slightly at various points to suggest a shadow behind the flowers and to set off the flowers themselves. However, the background remains essentially neutral, giving the flowers the center of the stage. Obviously, a more complex background would conflict with the intricate forms and colors of the bouquet. Even the vase in which the flowers are placed is radically simplified to a flat shape with only the slightest hint of tone to give it roundness, and a few touches to indicate an almost invisible pattern on the vase. It is important to recognize that only a few of the flowers are rendered with precision; almost all of them are patches of blurred color, out of focus and melting into one another, while a selected few have sharp edges. (Museum of Modern Art, New York, Gift of William S. Paley.)*

5

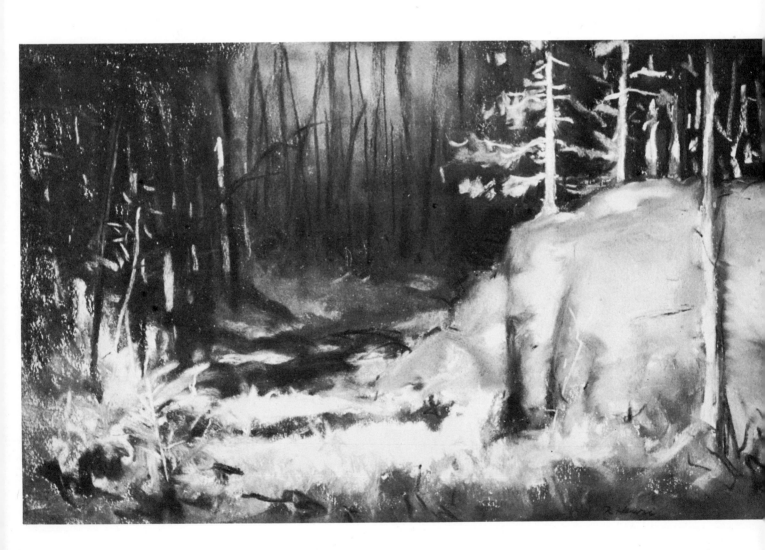

LANDSCAPE: MATERIALS

Probably most readers will use pastel for landscape painting more than for any other class of subject. It is so exceptionally fitted for sketching that one naturally proceeds, indoors, to more complete renderings in the same medium. The consideration of landscape in pastel, therefore, must include the whole process, from the first rough note to the last stroke on the picture, because problems of technique arise at every stage.

SKETCHING
FROM NATURE

Some artists use pastel solely as a means for making swift notes of fleeting effects, or to add a few suggestions of color to their drawings as an aid to memory. The technical methods employed for these purposes will usually differ considerably from those necessary for a more exact and detailed rendering. The inexperienced might conclude that a few colors would suffice for the former purpose. This, however, is a mistake that the first attempt will prove. The more one wants to suggest in a few strokes, the larger the number of colors one needs to choose from. If the nearest color in the box is not a close approximation to the one required, the sketch may be a dangerous means of deception later on, when the memory of the exact color has vanished.

It would not be practicable to carry a sufficient number of pastels to register

WHERE THE WOODS GROW DEEP by Robert Henri (1865-1929), pastel on paper, 12″ x 20″. *The artist used pastel much as he used oil paint, drawing large, broad strokes, and quickly blending them with the finger tip, but always enlivening the effect with further strokes which were allowed to stand untouched and unblended. Compare the soft, glowing modeling of the lighted hill on the right—where a lot of blending was obviously done—with the decisive, unblended strokes of the lighted treetrunks above. In the same way, the general dark tone of the forest in the background was achieved by soft blending, over which the crisp strokes of dark treetrunks were applied. Thus, an interesting interplay is developed between soft, blended passages and crisp, unblended passages. The entire effect gives the painting a feeling of power and spontaneity. (Photograph courtesy Bernard Danenberg Galleries, Inc., New York.)*

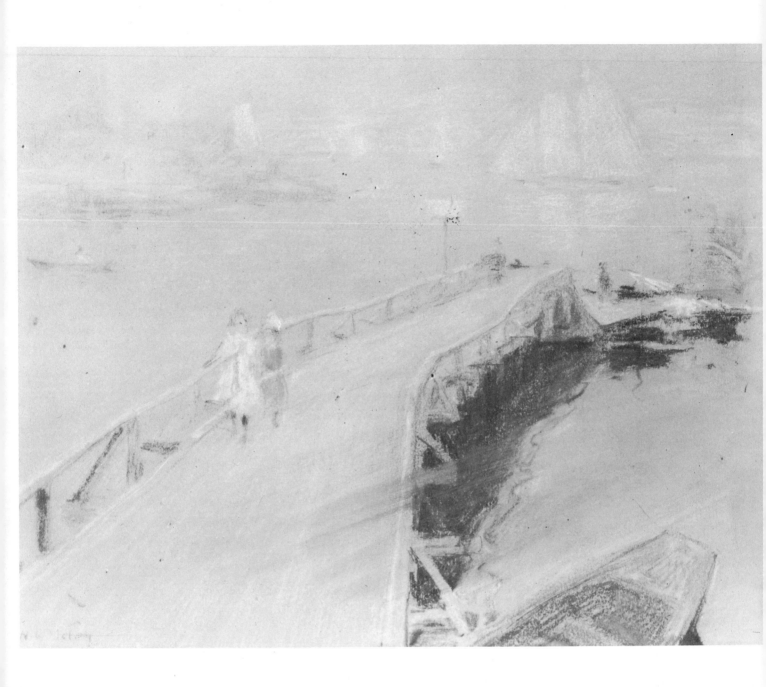

THE JETTY by W. L. Metcalf (1858-1925), pastel on paper. *Over the pale middle tone of paper, the artist has applied lighter strokes to indicate the jetty receding into the distance, the sails of the ships, their reflections, and the very pale distant landscape across the water. The only really dark notes are the reflection underneath the jetty, the boat in the immediate foreground, and a few touches of shadow along the railing. As is often true with the best pastels, the artist has applied a minimum of chalk, placing each touch with extreme care and allowing the underlying color of the paper to shine through and create atmosphere. (Collection Mr. and Mrs. Raymond J. Horowitz.)*

exactly the colors required in any summary sketch, but a little experience will soon show that certain colors are more often needed than others. Most blue skies, for instance, can be rendered in one or more of about half-a-dozen pastels. A few purplish grays constantly occur in distant trees and hills.

Under normal circumstances, apart from early morning and evening effects, the rendering of most landscapes in pastel calls for a far larger proportion of varied grays than of any other color. With landscapes which consist very largely of grass and trees, a considerable number of subtly muted greens are essential; and the infinite gradations of pale tints, warm and cold, in our clouds require several pastels for adequate rendering.

Further than this, it is impossible to be definite, owing to the variety of individual artists' tastes in the choice of subjects, in the differing characteristics of different districts, and the time of the year.

There is another aspect of the question which is of great importance to the experienced artist, but of little concern to the beginner. It is this: the artist seldom sets out to copy all he sees. He seeks material for the expression of his personal sense of beauty. After much experiment he generally finds certain color schemes which appeal to him more than others. These he adopts and develops, and, when sketching, selects those subjects which can be best expressed by those color schemes. He is able, therefore, to restrict the range of his palette and carry with him a larger number of pastels that come within that restricted range. The irresistible conclusion is to take as many pastels as may be conveniently carried.

SKETCHING
PAPERS

There is no need to stress the point that the tone and color of the paper is of vital importance when making a quick sketch. Much of the paper is likely to show through, and whole passages may remain uncovered. A subject with large masses of shadow can sometimes be sketched far more quickly and effectively on a dark, cool paper than on a pale, warm paper. The obvious thing to do is to choose a paper as nearly as possible like the tone of the shadow, or one by which the shadow can be expressed most quickly.

Speaking generally, the most suitable papers for sketching landscape are rather warm grays. Browns, especially the definite varieties, are generally unsuitable because so much of the surface needs to be well covered in most sketches with lighter and colder colors.

CHOICE OF SUBJECT

The sketcher in pastel may be surprised to find that in a short time he will begin deliberately to choose subjects which can be most easily rendered by the medium, and pass by equally interesting subjects which could be more readily sketched in watercolor. Bright lights on water, glistening leaves against broad shadows, are striking examples. For good or ill, sketching solely in pastel has been known to influence artists' watercolor technique, because so many of the subjects sketched in pastel were better suited to gouache than to transparent watercolor; and one (who happens to be the writer) does not regret it! Influences of this kind may be unfortunate, but there can be no doubt that to struggle unsuccessfully to produce an effect in pastel which can be expressed in watercolor with ease would be absurd. It is also pretty obvious that sketching in pastel will often most easily render a study which can be a successful preliminary to a picture in oils.

The subjects illustrated in Plates XXXVII, XL, XLIII, XLV, and L were chosen especially to show how the technique of pastel has influenced choice and treatment.

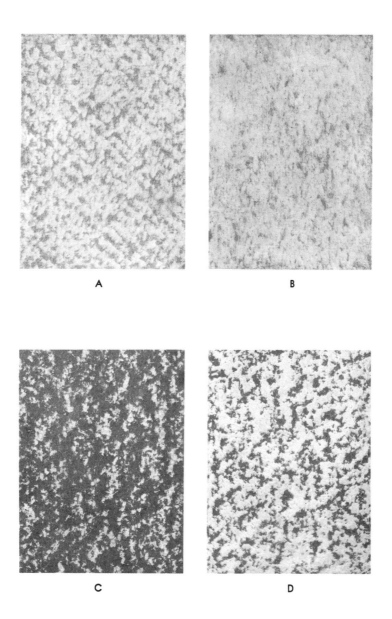

A B

C D

Plate I. INFLUENCE OF THE SURFACE OF THE PAPER. *The effect in A was produced by rubbing light gray pastel across a slightly ribbed paper. It gives the appearance of medium gray—a tone between the paper and the pastel—when seen at a distance. The mottling produces a sense of liveliness unobtainable by a flat tone. It suggests the texture of a rough material and would sometimes be useful in expressing distance. B was painted by superimposing the same light gray as before on a dark gray exactly the tone of the paper. The top layer has merged with the lower, and while the tone is about the same as in A, the texture is far less pronounced without being flat. C and D illustrate the effects of different pressures on coarse paper. In C, the pastel was laid on very lightly, producing a series of yellow dots on a ground of dark graybrown. In D, the pastel was laid on heavily, producing a series of dots of brown surrounded by yellow.*

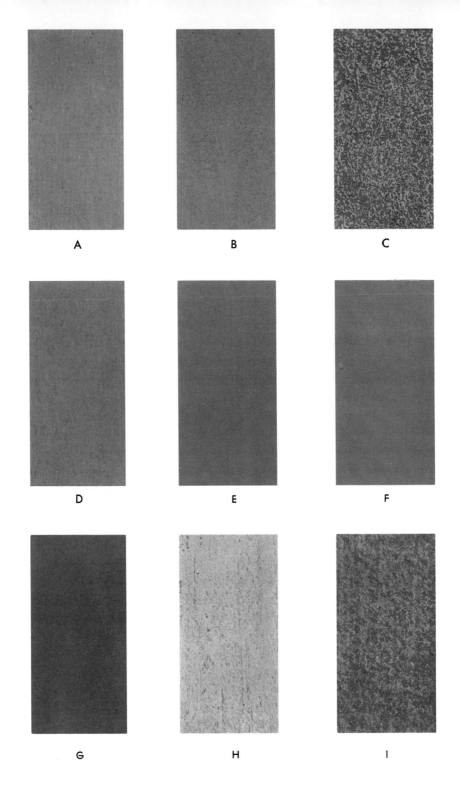

<div align="center">A B C</div>

<div align="center">D E F</div>

<div align="center">G H I</div>

Plate II. INFLUENCE OF THE PAPER UPON PASTELS OF OPPOSED COLORS. *In A, B, and C, green pastel was applied to red paper. In C, the pastel was laid on lightly so that there are about equal quantities of red and green showing. The effect at a distance is distinctly that of brown somewhat like F in color, but with an added effect of vibration. In B, the same pastel was laid on much more strongly and rubbed in so that a very small amount of the red paper shows through. The result is dark, rather warm gray-green. In A, the pastel was laid on in succeeding strokes till the red was completely covered. D, E, and F show some effects produced by using blue pastel on a rich brown paper. F shows the untouched paper. In E, the pastel was laid on very lightly and considerably rubbed in, producing a very warm dark gray. In D, the pastel was laid on much more strongly and very slightly rubbed in, giving an impression of bluish gray. G, H, and I illustrate two of the effects of using yellow pastel on blue paper. In I, the pastel was laid on very lightly so that a considerable proportion of the blue is seen. The effect at a distance is that of gray, somewhat like D. In H, the yellow almost obliterates the paper. G shows the original color of the paper and has not been touched.*

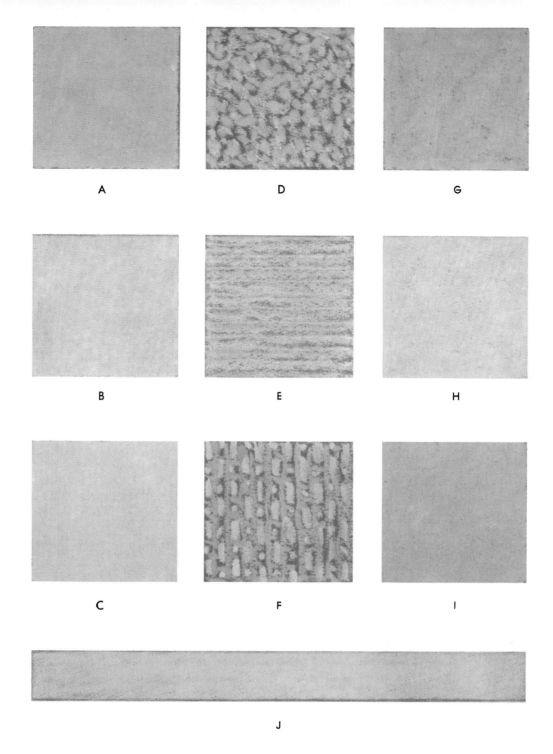

A D G

B E H

C F I

J

Plate III. VARIOUS EXAMPLES OF COLOR BLENDING AND DIRECT METHODS. *The three colors, gray, emerald green, and purple (G, H, and I), each represent the effect of using one pastel only, on a tinted paper, the color of which is seen in the reproduction. The three examples on the left (A, B, and C) were produced by superimposing the first-mentioned colors (G, H, and I) on a prepared ground of yellow ochre of precisely the same tint as J. Yellow ochre makes a profound effect when used in conjunction with other colors and invariably produces harmonious tones. The three examples in the center (D, E, and F) were obtained by using the same colors as above, but without superimposing or blending one tint into another. Each spot, line, or curve should be done with definite—and as far as possible separate—touches of the paste stick. Many intriguing patterns and textures can be evolved by using this method of pastel technique.*

Plate IV

Plate V

Plate IV. ONE-COLOR DEMONSTRATION (FIRST STAGE). *This is the first stage of a two-stage demonstration (continued in Plate V) on tinted paper in which yellow ochre only was used. A preparatory ground was made by a thin layer of yellow ochre pastel which was delicately applied to the paper and then rubbed well into the paper with absorbent cotton. On this ground, suggestive cloud and water forms were made.*

Plate V. ONE-COLOR DEMONSTRATION (SECOND STAGE). *In this continuation of the demonstration begun in* Plate IV, *the sky was generously covered—but not solidly—with yellow ochre, while retaining the original cloud formations.*

Plate VI. THREE-COLOR DEMONSTRATION. *The subject introduced in Plates IV and V shows further development. Whereas, in Plates IV and V only one color was involved, in this example, three colors were used. Cerulean blue for the sky mingled excellently with the yellow ochre ground, and white pastel also blended well with the same ground color.*

Plate VII. FIVE-COLOR DEMONSTRATION. *Here, the three-color demonstration illustrated in Plate VI is carried even further, adding ultramarine blue and brown madder to help complete the hills and foreground material. The contours of the clouds, distant hills, etc., were softened by rubbing the pastel very gently with the hand. The five colors placed centrally between the two color sketches (Plates VI and VII) represent the number of tints used in Plate VII.*

Plate VIII. USE OF TWO HARMONIOUS PASTELS (FIRST STAGE). *This and Plate IX constitute a simple but effective demonstration, involving the use of two pastels only—gray and dull purple. These two colors are also centrally placed between the two sketches.*

Plate IX. USE OF TWO HARMONIOUS PASTELS (SECOND STAGE). *It is instructive to note that the two gray tints in the sky below came from the same stick of pastel. The darker gray was made by rubbing in the pastel, and the solid gray was afterwards worked on top of the ground tint. The suggestions of foliage, trees, etc., were made by varying degrees of pressure on the paper with the purple and gray pastel. A limited number of pastels is a valuable asset for suggesting the pattern or composition of landscape and figure subjects. For outdoor landscape sketching, however, the difficulty is to get enough pastels to convey the intricacies of nature.*

Plate VI *Plate VIII*

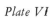

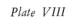

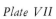

Plate VII *Plate IX*

53

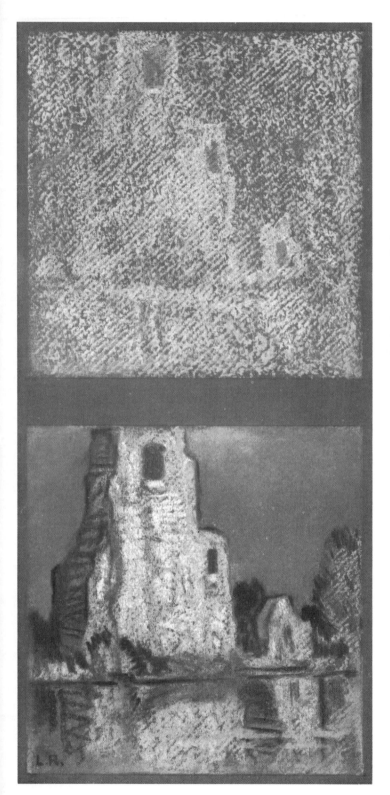

Plate X. SUGGESTIVENESS OF PASTEL (FIRST STAGE). *This demonstration was done on a paper of pronounced texture. Gray pastel was placed over the whole of the picture. The rough surface of the olive green paper becomes very noticeable when the pastel is used in a direct manner without superimposing another color, or rubbing the pastel into the grain of the paper. No previous consideration was given as to what the pictorial subject might be. The indiscriminate use of light yellow ochre—on and into the gray ground—suggested some affinity to the remains of an ancient building.*

Plate XI. SUGGESTIVENESS OF PASTEL (SECOND STAGE). *In this continuation of Plate X, brown madder pastel proved invaluable for strengthening the first impression alone. The sky was lowered in tone by rubbing off a good deal of the gray pastel with absorbent cotton and the light on the crumbling masonry was reinforced by the application of white pastel.*

Plate XII. Six Examples of Pastel Painted over a Pre-
pared Watercolor Ground. *The center column of this
demonstration (G, H, I, J, K, and L) shows the result of using
pastel over a preparatory ground, painted in watercolors on
white canvas-grained paper. The various watercolors for the
preparatory ground can be seen on the left, the corresponding
pastel on the right, and the finished central demonstration in
the center. For instance, G was originally painted over with the
same watercolor tint as A and when dry, the corresponding
pastel color depicted in M was carefully—but not too solidly
—spread over the watercolor ground. Each of the lower exam-
ples was treated in the same way.*

List of Watercolors used:

A Chrome
B Orange chrome
C Purple
D Hooker's green
E Burnt sienna
F Ivory black

List of Pastels used:

M Lemon yellow
N Yellow ochre
O Gray
P Light green
Q Light red
R Purple madder

Plate XIII. STUDY OF THE TEXTURE OF VELVET. *This study (reproduced the full size of the original so that every stroke can be seen clearly) is an evidence of how the technical method is influenced by the texture of material and the color of paper. It was painted on rich brown paper, which is left untouched at the top. Combined with dark red, it gives the color of the shadows and, combined with bright red-orange, it gives the color of all the surface which is neither in strong light nor in shadow. Varied pressure was used to express varieties of light and shade. The pale pink touches were superimposed with fine, crisp strokes when the rest of the drawing had been completed.*

This, the simplest of all methods, is especially suited to the expression of this kind of texture. But it would seldom be possible to adopt it in a picture. If, for example, the subject contained two velvets of different colors, the same paper could not form a suitable basis for both, and this particular color is seldom suitable as a background for the whole of any picture. The only way to get this effect in such circumstances is to rub in a background on the surface where required. In the present case, brown pastel rubbed in so that nothing would be dislodged when worked over would have much the same effect as brown paper.

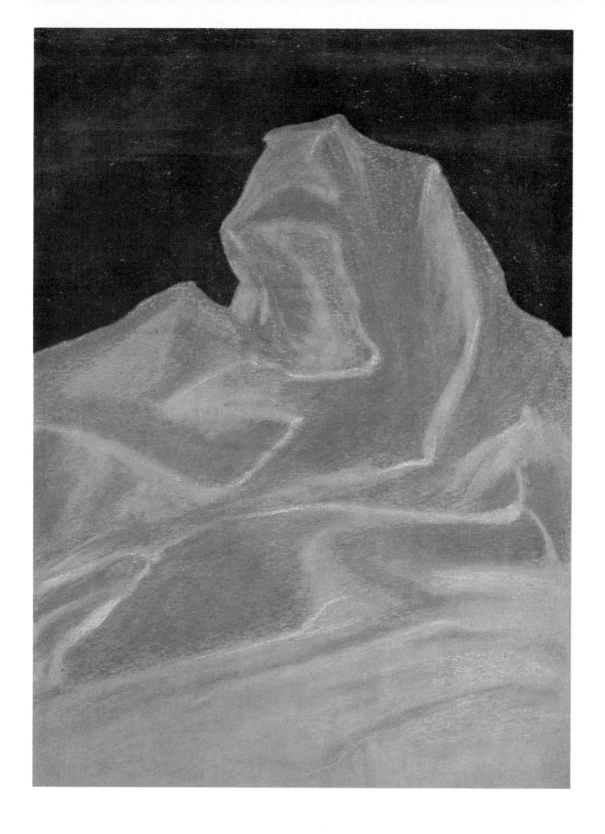

Plate XIV. STUDY OF THE TEXTURE OF SHOT SILK. *This study is another illustration of the influence of the material on the technical method. It differs from Plate XIII in every way. To obtain the effect of smoothness and sharpness, thin lines were used throughout, and, in all except the final strokes for the highest lights, every color was lightly rubbed in. More rubbing-in would have given more smoothness, but the differences in color would have been lost. Gray paper was chosen, because it modifies all the bright colors when they are lightly applied.*

Commence by painting the whole of the darker parts with varied pressure as required. Rub in lightly. Next, paint the darkest parts and rub in very lightly. Then add the light blue strokes, and rub in still more lightly. Complete with sharp touches without rubbing in. For the background, cover the whole surface solidly with black, but do not rub in. On this, paint a few strokes of dark gray, which will merge into the black, producing the soft texture of rather dull black velvet, which will contrast nicely with the blue silk.

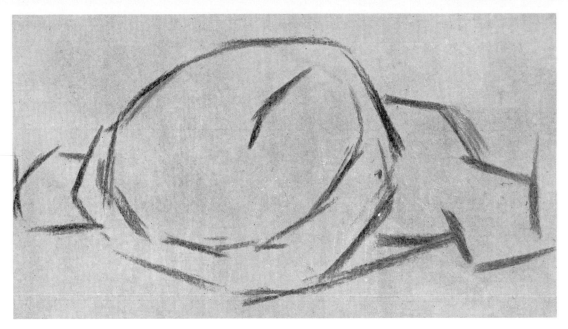

Plate XV. First Stage of Preliminary Charcoal Sketch for Cushions (Plate *XVII*). *As some readers may not be adept at drawing and composition, some of the subjects are illustrated and explained in the preliminary stages of preparation for the actual painting in pastel. Much time is often wasted by the lack of systematic method, frequently resulting in faulty form. A clean and exact method of drawing is especially important in pastel painting, as unerased lines sometimes spoil the appearance of the final picture and the surface of the paper is generally ruined by the use of an eraser. In drawing the cushions, the first thing is to make certain of the proportions. Draw in charcoal, very lightly, two short upright lines, one on the extreme left and the other on the extreme right.*

These two lines indicate the greatest width and must not, on any account, be altered. The distance between these two lines may be anything the student decides. It settles the size that the drawing is going to be made. Next, draw two short horizontal lines, one touching the highest part of the drawing and the other touching the lowest part. It is of the highest importance that the distance between these two lines should bear the correct proportion to the other two, i.e., the exact difference between the height and width of the whole group. This done, draw two more short upright lines to show the exact width of the front cushion. When these proportions are ascertained beyond doubt, roughly sketch in the broad lines of the general shape and ignore all details.

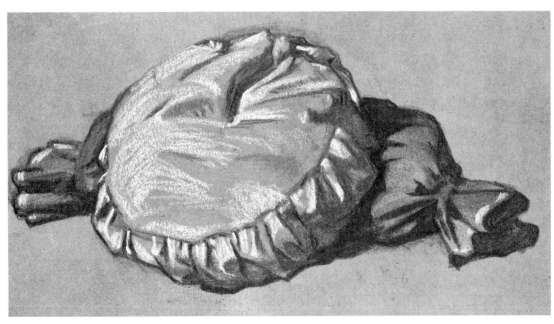

Plate XVI. Second Stage of Preliminary Charcoal Sketch for Cushions (Plate *XVII*). *When the first stage of the drawing is correct (Plate XV), dust the drawing lightly with a clean cloth. If the drawing is made with light strokes, only very faint lines will be left on which to make the final drawing in very careful outline. Then concentrate attention on the light and shade. Cover all the dark parts with a flat tone.*

The tone should be such that the shades can be completed by additional tone, not by rubbing out. Next, define the darkest parts, in this case the shadows. Then complete the details in the shades. For the lights, take white chalk, using the point, and finishing with clean strokes for the highest lights. No white chalk is used on the black cushion because the lightest parts are darker than the tone of the paper.

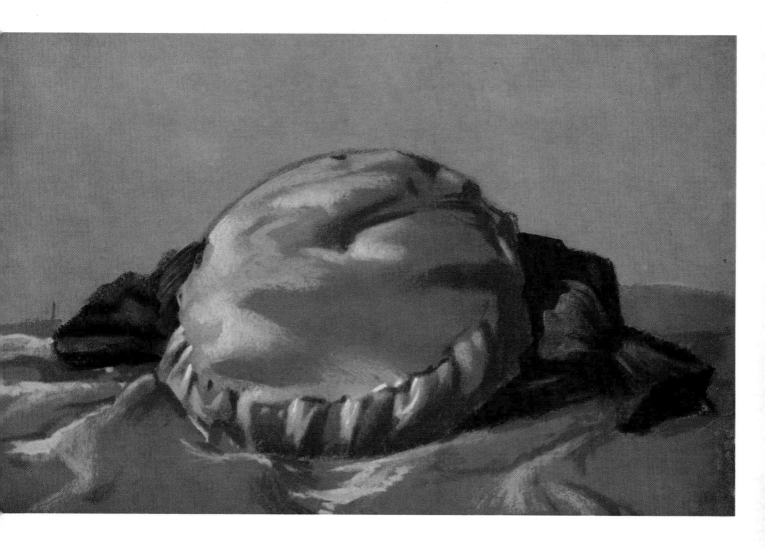

Plate XVII. Cushions. *This study is a practical application of the studies in Plates XIII and XIV in the expression of three kinds of texture. As the color of each object is distinctly different from the others and from the background, each has a rubbed-in background. Each part should be well rubbed in so that the superimposed strokes will not blur, except in the black cushions where the effect of dull velvet is better expressed by painting the gray lights into the unrubbed underpainting. Lay on the pastel, preferably with the side of short pieces of pastel. It is better to begin by laying on too little, and to repeat the process two or three times, rubbing it in each time rather than putting on too much at first and having to take it off. All the details of form cannot be preserved in this stage, so it is useless to draw them. But the previous study in black should be a sufficient preparation for direct painting in the second stage without the help of detailed outlines. Great care should be taken to get this stage exactly right in general shape, tone, and color, because any subsequent corrections will inevitably be noticeable as evidences of bungling technique. This method is not necessarily the best. Any surface or color can be expressed without any rubbing in, or parts of the picture may be rubbed in to any extent; but it is certainly the simplest method, and requires the least number of colors. The final strokes serve two purposes: (1) to define the shapes, especially at the edges, and (2) to give that crispness and fresh spontaneity which is so characteristic of pastel.*

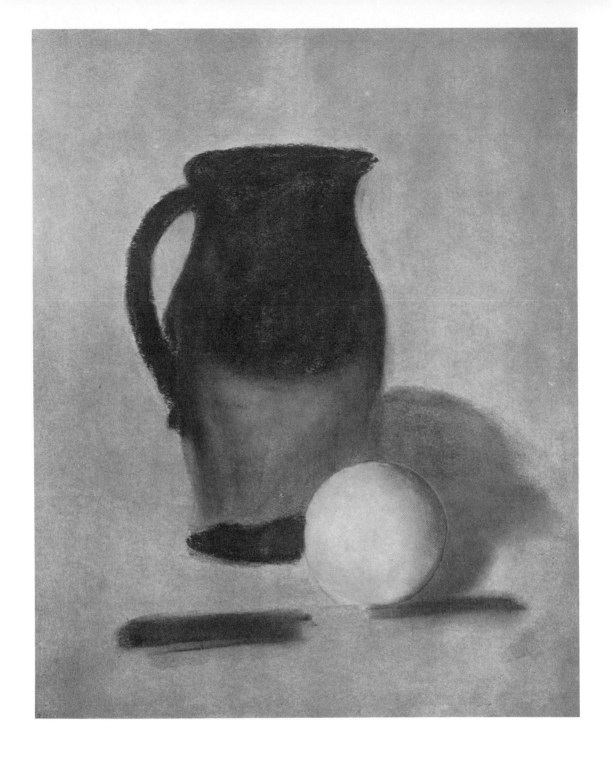

Plate XVIII. A BLACK JUG (FIRST STAGE). *The method illustrated here and in Plate XIX is of exceptional interest. It shows how an apparently accidental smudge can be turned into a regular shape, with edges as sharp as required, and display evidences of commendable efficiency. The present example lends itself especially to this treatment—a dark object standing in front of a flat, light background. The obvious method is to draw the jug carefully in every detail, lay on the black pastel where required, leave every part untouched which is of the same tone as the paper, and finish with strokes of grays and white. This method, in most cases, may be preferable, but, in*

the present instance, the dark object (the jug) has an exceedingly shining surface which can be most adequately expressed by rubbing in black and dark gray. But, as you can see in this first stage, one inevitable result of rubbing-in is to lose the edges and all the other detail. Rubbing in a background also would intensify the difficulty. This combination of crispness and softness is sometimes more expressive than when unrubbed pastel is used throughout. How much of the painting is best done by definite strokes depends upon several factors; usually it is well to see that the crispness resulting from strokes (with the side or the point) occurs in most parts of the picture.

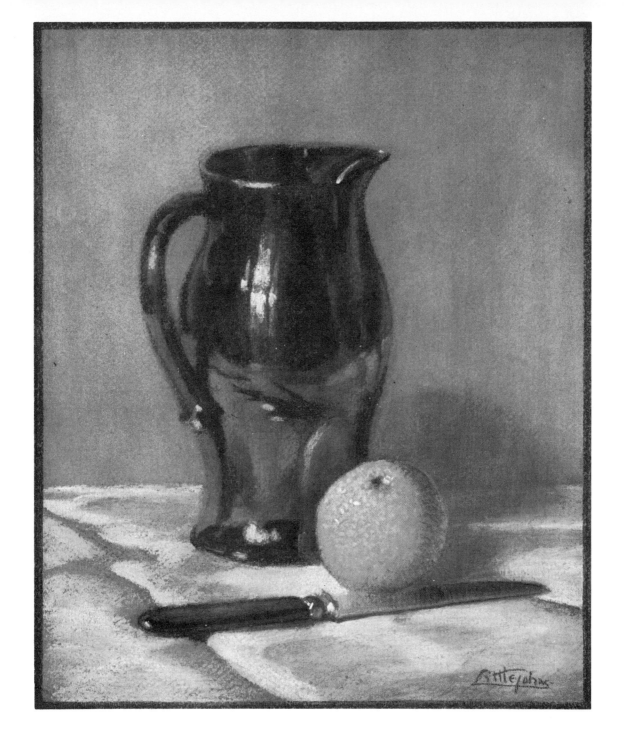

Plate XIX. A Black Jug (Second Stage). *Go over all the uneven table cloth with horizontal strokes of varied grays. Most of the surface will be the same as the background. Next, paint the handle of the knife in black and rub in hard. Complete the cloth with firm strokes of white pressed into the gray. By varying the pressure, every difference of tone can be expressed. The underpainting of the orange will require a little dark brown and two or three varieties of orange and yellow-orange slightly rubbed in. The characteristic roughness of the surface can best be obtained by making separate dots ending with the lightest. Complete the jug and knife with sharp touches of intense black, pure white, and two or three grays. Draw the general shape of the jug. Rub in the upper part with black, the lower part and the shadow in the background with* dark gray. *Be sure that it is rubbed in so hard that none of the pastel will merge with superimposed strokes. Next, turn the picture upside down, take a short piece (about ¾″ long) of the required gray pastel and, using the side, go around the outline correctly, making a clean sharp edge. Cover the whole of the background with vertical strokes laid on so that the whole surface is perfectly flat. Press lightly and go over every part as often as required. With a suitable paper (such as that illustrated in Plate I, Figure A) the result will be a pleasant granular surface—interesting without being obtrusive. The whole picture needs to be painted with great confidence. If two or three attempts are required, the power of technical command thus developed will be found to be of great value in treating a large number of subjects.*

Plate XX. First Stage of Preliminary Drawing for A Dutch Jug (Plate XXIII). *The drawing of subjects of this type may involve the beginner in irritating and unnecessary difficulties in the absence of a systematic method. Objects are noticeably faulty if slightly inaccurate; and one small mistake in proportion can alter the whole appearance of the group. It is generally best to make a series of exact observations before beginning to draw. In this case: (1) the position of the jug—quite by accident it happens to be in the middle of the picture; (2) the relative proportion of height to width—the height is nearly twice the width; (3) the proportions of principal divisions—it so happens that the divisions AB, BC, and CD are almost exactly equal to half the width CG, and DE is half CD. The width of the pedestal (HJ) is the same as FG. This is a series of fortunate circumstances which renders the first stage of the drawing very simple. But, whatever the proportions, they should be observed accurately and registered as shown.*

Plate XXI. Second Stage of Preliminary Drawing for A Dutch Jug (Plate XXIII). *This second stage shows how easily all the main lines of the picture can be drawn when the main proportions have been found. One point in the composition deserves notice. The jug is exactly in the center—which is usually a blunder. Here it does not appear to be in the center because of the unsymmetrical character of the rest of the group.*

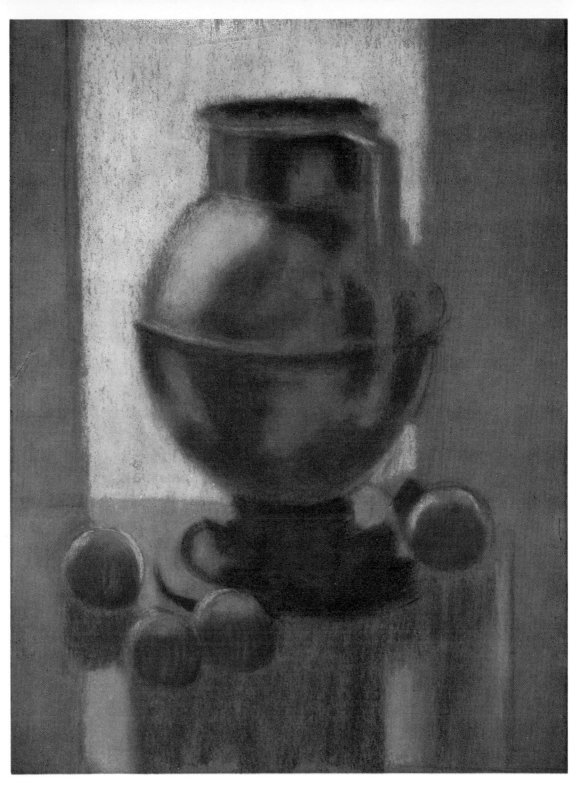

Plate XXII. A DUTCH JUG (FIRST STAGE). *As the prevailing coloring of much of this picture is gray-brown, a paper was chosen so that the least amount of color need be applied in order to paint the gray-brown parts. The differences between these parts and the actual paper can be seen by comparing the finished picture (Plate XXIII) with the partly-finished illustration shown here. After the preliminary studies (Plates XX and XXI), there should be no difficulty in making a careful drawing in charcoal without details which are likely to be lost. Dust off the superfluous charcoal so that only faint lines remain. Next, lay on a sufficient quantity of each pastel which, when rubbed in, gives the undertones. Begin preferably with colors which differ distinctly from the color of the paper. It is* *better to put on a little and add more than to put on too much. Every part should be rubbed in so that nothing can be dislodged in the subsequent painting. Great care should be taken to get every part exactly right, in tone as well as in color, as mistakes will be intensified when the second stage is painted. When the main passages are right, look for the variations— those subtle differences in tone and color which are largely responsible for the expression of differing surfaces. The defining of edges cannot be shown in this stage, but every part should be ready so that the whole picture can be completed in the second stage with the minimum number of clean, sure strokes. Most of the color can be laid on best working with the pastel held on its side.*

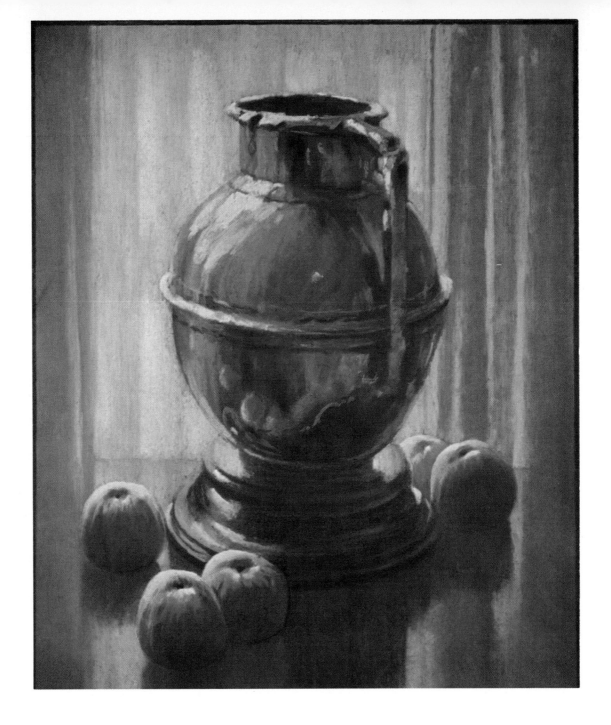

Plate XXIII. A Dutch Jug (Second Stage). *In spite of the striking difference between this finished picture and that of the partially-drawn first stage (Plate XXII), the student should have little difficulty, by this time, in following the course of evolution. All the dark parts (except the darkest strokes on the jug and the ebony pedestal) should be laid on before any lights are painted. The lightest touches on each object should be painted last. To express the effect of sunlight through the gauze window blind, the pastel required for the lights should first be taken over the whole surface very lightly,* the side being used; the lights are got afterwards with greater pressure and firmer strokes. Experience will soon prove that an exact imitation of burnished surfaces can falsify the form. Tones and colors, reflecting different parts of the room behind the spectator, may spoil the color harmony. It is usually unwise to introduce into these reflections many accidental colors unrelated to any of the others. The beginner always tends to overemphasize the differences in tone, and should make careful comparisons with the lights and darks in other portions of the picture when painting the reflections.

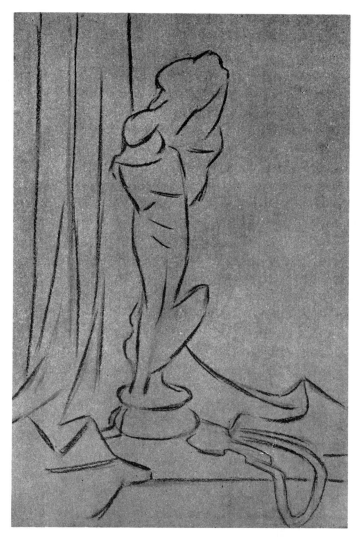

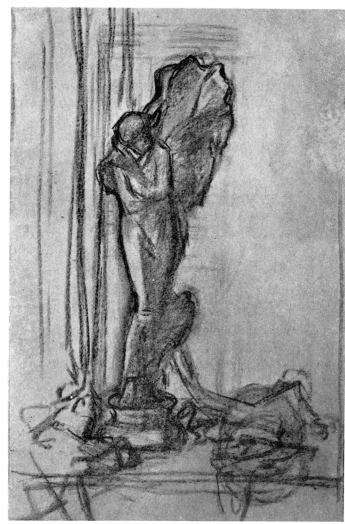

Plate XXIV. First Stage of Preliminary Study for The Statuette (Plate XXVI). *Concurrently with the drawing of this subject, the composition should be carefully considered. For, in this case, the success of the picture depends to an unusual extent upon the arrangement. In particular, the placing of the figure and the lines of the drapery are deciding factors. This plate shows the first rough sketch of the conception. The right-hand side of the picture is left untouched so that the figure can show clearly, although the edges are not very definite. The drapery on the left falls in long radiating folds forming a varied background at the bottom of the picture. The action and general proportions of the figure have been indicated with some suggestion of light and shade. But it is only a rough sketch and subject to alteration.*

Plate XXV. Second Stage of Preliminary Study for The Statuette (Plate XXVI). *This study was drawn from the group after it had been rearranged in order to emphasize the rhythmic lines which form the basis of the composition. The most important change is the addition of the beads which complete the scheme of radiating lines. The figure has been treated in the same way, preparatory to the drawing of details. Everywhere there is an emphasis upon rhythm.*

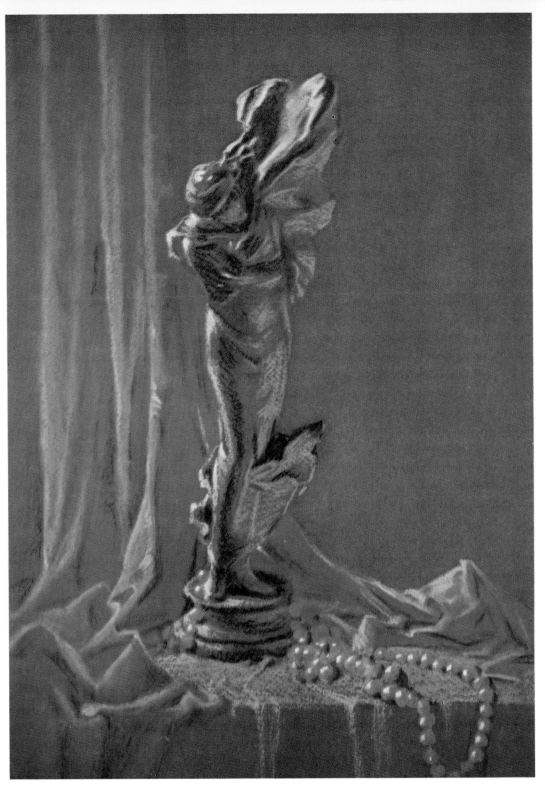

Plate XXVI. THE STATUETTE. *Here is an example of the great part which the paper can be made to play. Quite half of the surface is completely untouched, and in the remainder the pastel is applied so lightly that much of the paper shows through, except for the few strong touches which cover the paper completely. No part is rubbed in. This method, simple as it appears, admits of no corrections. The drawing must be exact and every part of the operation decided before the painting is begun; because every stroke tells, and none can be hidden by subsequent applications. The composition of every line must also be settled before the final drawing is made. The two sketches in Plates XXIV and XXV show how this subject was evolved. This illustration is reproduced on a scale sufficiently large to show each stroke. It shows how the main tones are expressed, separating the figure and the drapery from the background. The reflected lights on the right side of the figure, and the half-lights on the other side, are done in lines in order to define the forms. On the drapery, the side of the pastel was mainly used. The few lines on the table serve to indicate the color and tone, as well as the position of the beads. Although the whole of this stage consists of a few strokes of considerable exactness, the effect is striking, completely changing the appearance of every part of the picture. Every stroke must be drawn with certainty. First paint the darks on the figure, except the highest lights, and then the strong lights. Next, treat the drapery in the same way, and then the beads.*

66

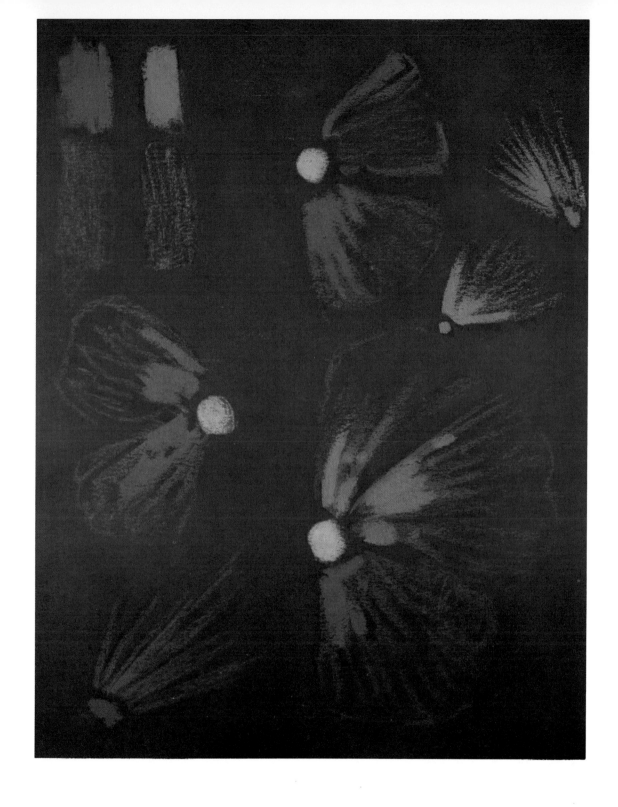

Plate XXVII. PREPARATORY DEMONSTRATIONS FOR STUDY OF BEGONIAS (PLATE XXVIII). *Here are a series of demonstrations in color, showing the most practical method of getting a constructive style in pastel handling. The two examples on the left at the top corner show a solid or opaque touch of crimson and orange chrome. The darker color immediately below is, in each case, derived from the solid color above. It was obtained by pressing very lightly with the pastel on the dark gray paper. The three progressive examples of petals were manipulated with the same feeling of pressure as stated above. The addition of orange chrome helped to intensify the light on the crimson petal in the larger demonstration at the foot of the reproduction. Full information is given in Chapter Three.*

67

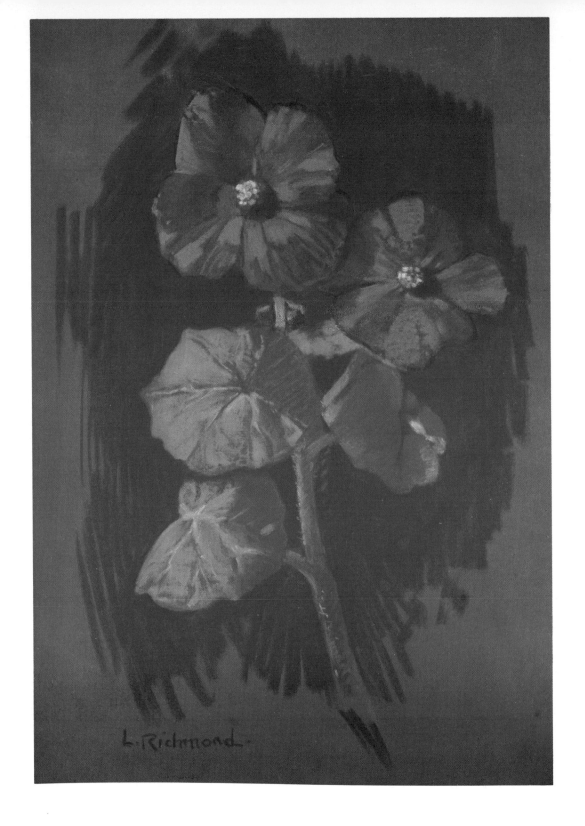

Plate XXVIII. STUDY OF BEGONIAS. *In the previous reproduction (Plate XXVII) relating to the handling of crimson and orange chrome, it is noticeable that the lines of each petal radiate from a given point, i.e. the center of the flower. The same principle is adopted for this finished* Study of Begonias.

The addition of a reddish purple in the shadow portion of the petals was dark enough to emphasize the shadow, yet sufficiently bright to harmonize with the adjoining light portions. The large leaves were painted with light and warm gray on top of a ground tint made with fairly dark green.

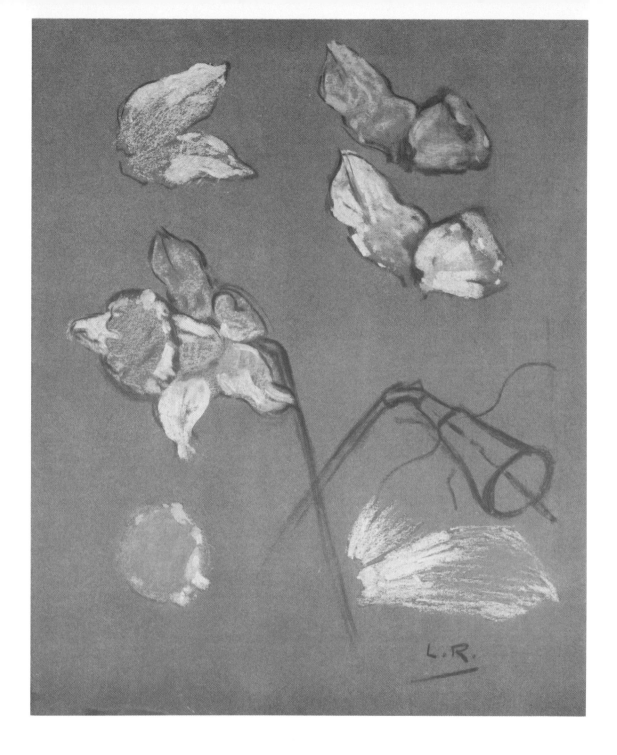

Plate XXIX. Preparatory Demonstrations for Study of Daffodils (Plate XXX). *The top example on the left shows how easily two tones can be made with lemon yellow on tinted paper. To get opaque highlights it is necessary to exert strong pressure with the pastel. Conversely, the shadows require but little pressure so that the tinted paper below is able to show its presence through the thin layer of lemon yellow.*

The two demonstrations at the top right represent the first and final stages of daffodil petals with a foundation of bright green. Lemon yellow mixes admirably with light green without any loss of color purity. The same atmosphere of light green is noticeable in the daffodil centrally placed on the left. Full information is given in Chapter Three.

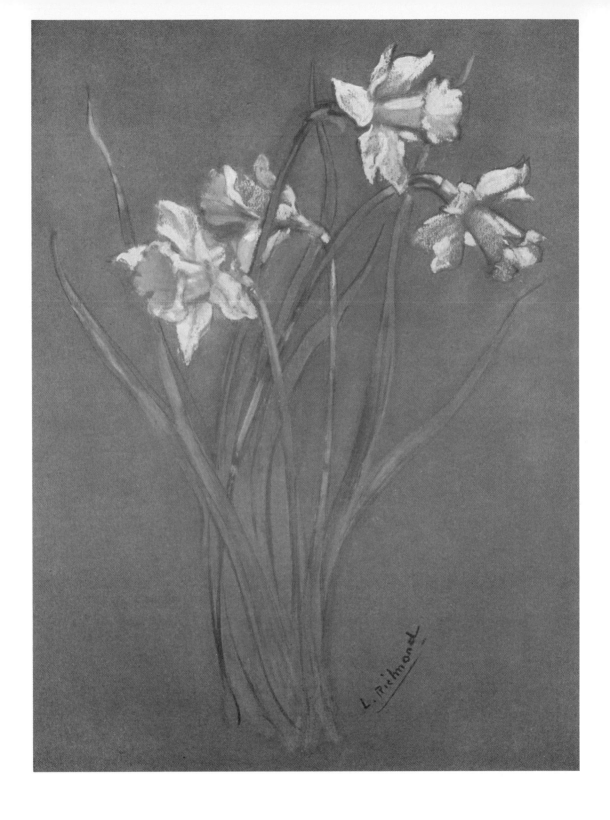

Plate XXX. STUDY OF DAFFODILS. *The four daffodils depicted in this reproduction were each drawn carefully in charcoal before any color was introduced. Only the brightest colors should be used for flowers of this type. Lemon yellow, chrome,* *light green, and a little light gray comprise the necessary colors for these daffodils, provided always that the tinted paper underneath is allowed to assist in getting the correct tone values. Full information is given in Chapter Three.*

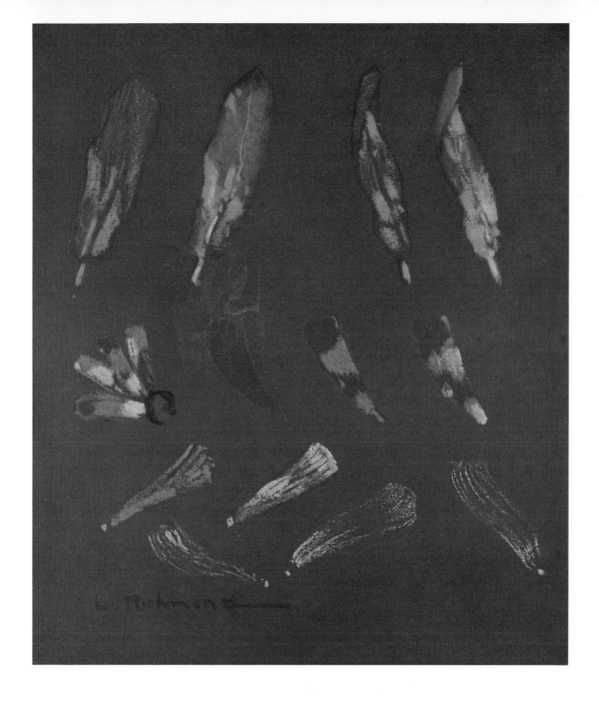

Plate XXXI. PREPARATORY DEMONSTRATIONS FOR A GROUP OF MARIGOLDS (PLATE XXXII). *The four leaves on the top line are shown in two stages. Commencing on the left, the first leaf—after a preliminary charcoal outline—received a suggestion of light and shadow with one pastel only, namely, Hooker's green. Three colors were necessary to complete the adjoining second leaf. For the shadow, dark green was used fairly solidly, and judicious touches of light gray in places, on* *top of the Hooker's green, completed the study. The two leaves on the right were treated in precisely the same manner. The three petals depicted in the middle line below the leaf studies were done in three stages: the first is burnt sienna; the second, orange chrome on top of the burnt sienna; and the third, lemon yellow on top of the orange chrome. The four adjacent petals were done in the same method. Examples of line treatment are shown at the foot of the reproduction. See Chapter Four.*

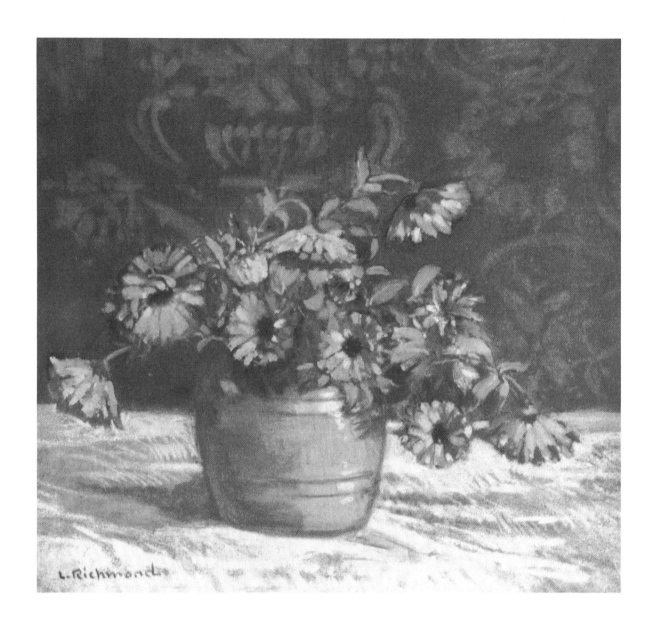

Plate XXXII. A GROUP OF MARIGOLDS. *The same treatment for the petals and leaves of marigolds as advocated in the previous plate description was adopted for the group in this picture. Burnt sienna, orange chrome, and lemon yellow were used for the flowers, and Hooker's green with gray for the leaves. The color of the paper on which this group was painted is exactly the same dark gray seen in the previous plate.*

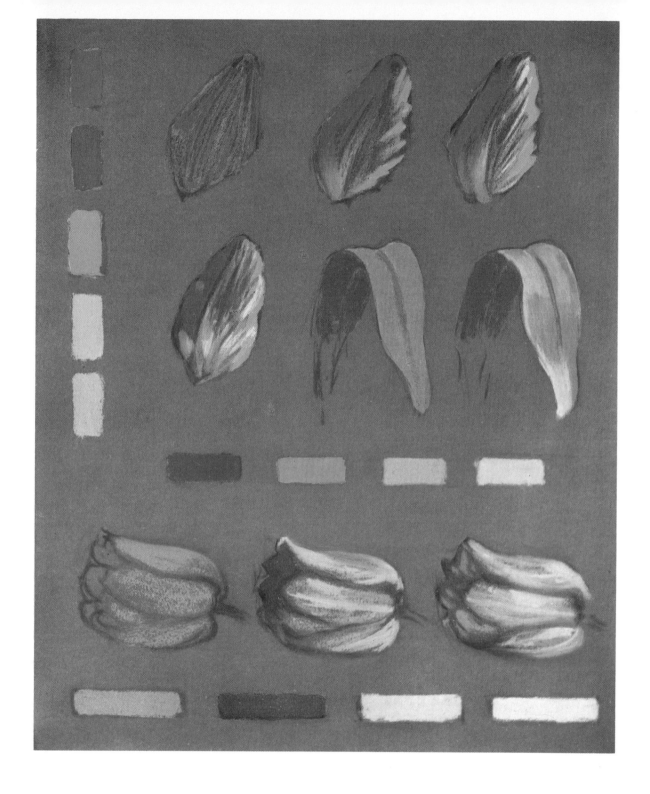

Plate XXXIII. Preparatory Demonstrations for Tulips in a Glass Jug (Plate XXXIV). *The five tints placed in a vertical line on the left represent the number of colors required for painting the final stage of a tulip petal. The first, second, and third stages can be seen on the top line, and the finished petal immediately below the first example.*

The four tints placed directly below the two drooping leaves indicate the necessary colors for completing the finished leaf seen on the right. Three stages are shown of a light-colored tulip with the corresponding tints used for this purpose, placed horizontally underneath. The various methods are described in Chapter Four.

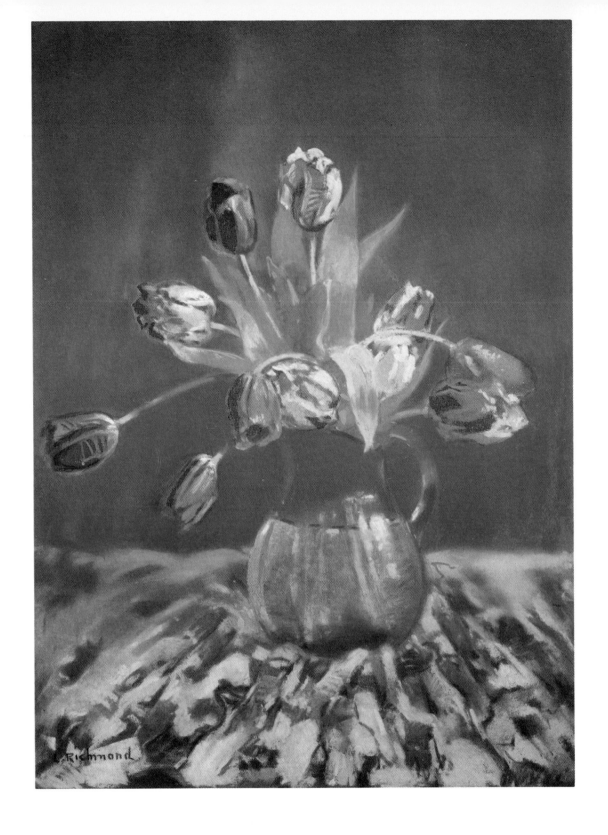

Plate XXXIV. TULIPS IN A GLASS JUG. *In this study of a gay group of tulips in a glass jug, the bright-colored flowers were placed in front of a bluish background so that the bright red, yellow, and white seen in the various tulips could be dis-* *played to advantage against the colder material behind. The numerous colored drawings depicted in Plate XXXIII, with further information in Chapter Four, supply all the necessary detail required for painting tulips in pastel.*

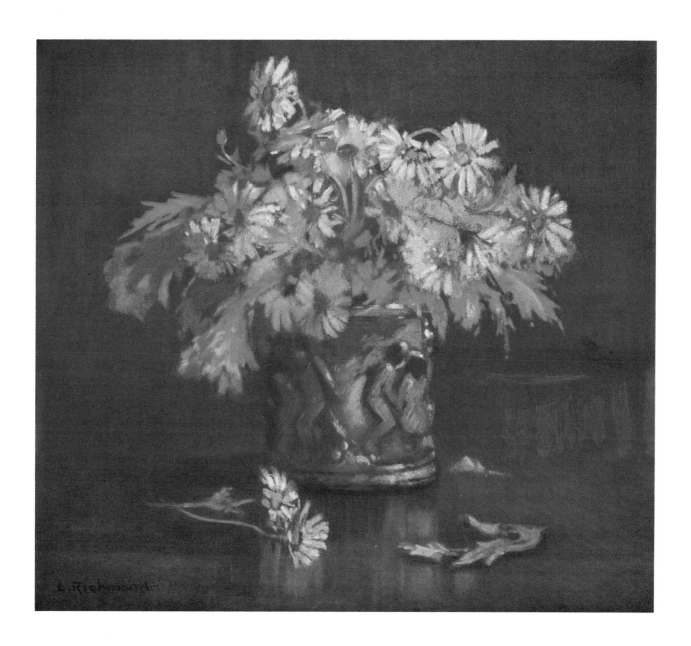

Plate XXXV. YELLOW DAISIES. *The numerous yellow daisies in this picture were drawn with rapidity in an attempt to get the spirit of the subject rather than a slavish imitation of flowers. The color of the flowers is deep chrome for the centers, yellow ochre and white for the light petals. Most of the flower petals in shadow are made with light gray worked over deep yellow ochre. The leaves are ordinary green with touches of emerald green, light and dark gray. The dark colors used for the bowl are ivory black and burnt umber, while the other colors consist of Prussian green and russet green, in addition to three or four light touches of emerald green and orange chrome.*

Plate XXXVI. A Sussex Bridge (First Stage). *Use a light brownish paper, shown in the road, which is untouched with pastel in this stage. Draw the outline of the main features lightly in charcoal. Cover the bridge with dark purplish gray and rub in quite hard. Rub lighter and cooler gray into the reflection. Cover the whole of the sky with a color rather lighter than the paper. Go over the whole surface lightly with the side of the pastel. Rub in lightly till the whole is even, but some of the paper shows through. Next paint the distance with pale blue-gray to make the tone almost flat. Use rather strong pressure. If the sky is not satisfactory, go over it again with the side of the pastel, using whatever will correct the color and tone. In the end the paper should show through slightly, giving your picture a pleasant, granular surface. Start painting in the foreground with strokes of brown and greenish gray pastel, but do not rub in.*

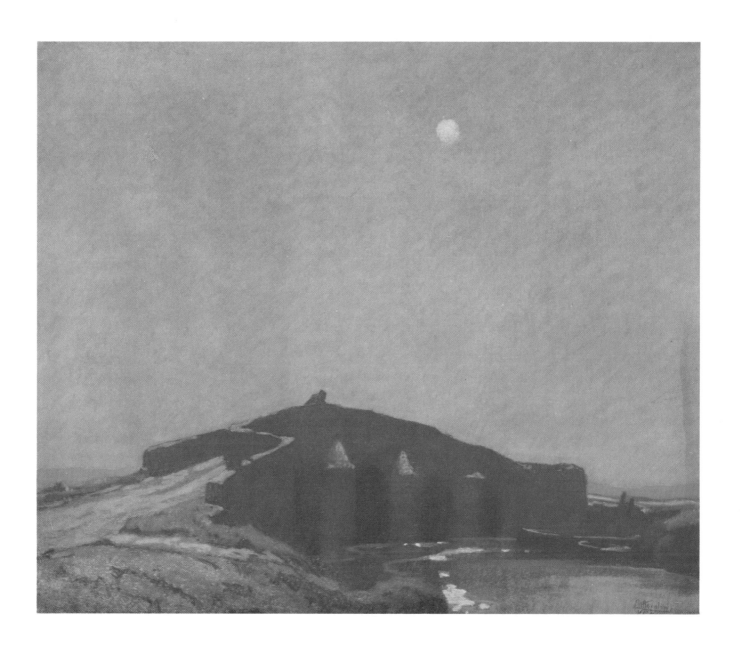

Plate XXXVII. A SUSSEX BRIDGE (SECOND STAGE). *The picture begun in Plate XXXVI can now be completed with a few careful, well-defined strokes. First, see that all the dark edges are clear and sharp where needed. Then add the dark brown strokes on the foreground, and define the very dark gray boats and shadows in the arches. When all the dark parts are completed, draw the lights on the bridge, road and boats with sharp touches of pale, warm gray slightly lighter than the sky. Finally, paint the moon and its reflection.*

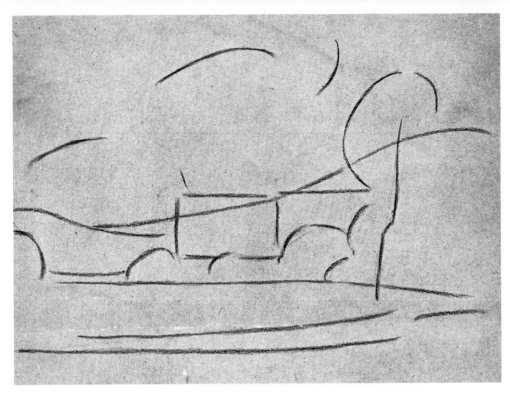

Plate XXXVIII. PRELIMINARY NOTE OF PICTORIAL CONSTRUCTION FOR BOLTON ABBEY (PLATE XL). *To sketch pictorially one must see the forms and colors of things in the scene as a constructed whole before commencing the drawing. To do so, one or more preliminary notes may be needed before* the conception takes clear shape in the artist's mind. Plates XXXVIII and XXXIX are two notes made in pencil immediately before Plate XL was painted on the spot. This note serves two purposes: (1) it fixes the position of the parts, and (2) it brings them into harmonious relationship.

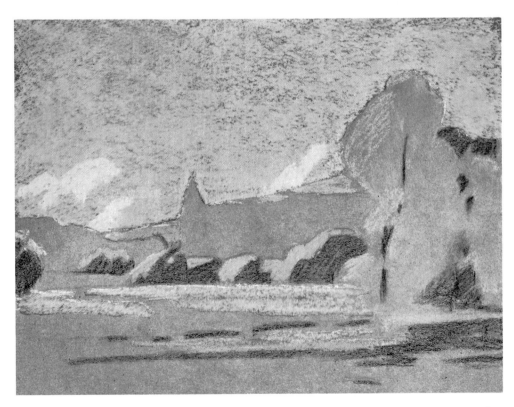

Plate XXXIX. PRELIMINARY NOTE OF TONES FOR BOLTON ABBEY (PLATE XL). *The object of this note is to define and simplify the main forms. Disregarding the color, for the time being, it registers the relative tones of the principal masses. For example, the building is slightly darker than the near trees,* and exactly the same tone as the middle distance on the extreme left of the picture. These tone relations should be observed correctly before beginning to paint, especially when, as in the present example, the distinctions are very subtle. This note shows the main masses in process of definition.

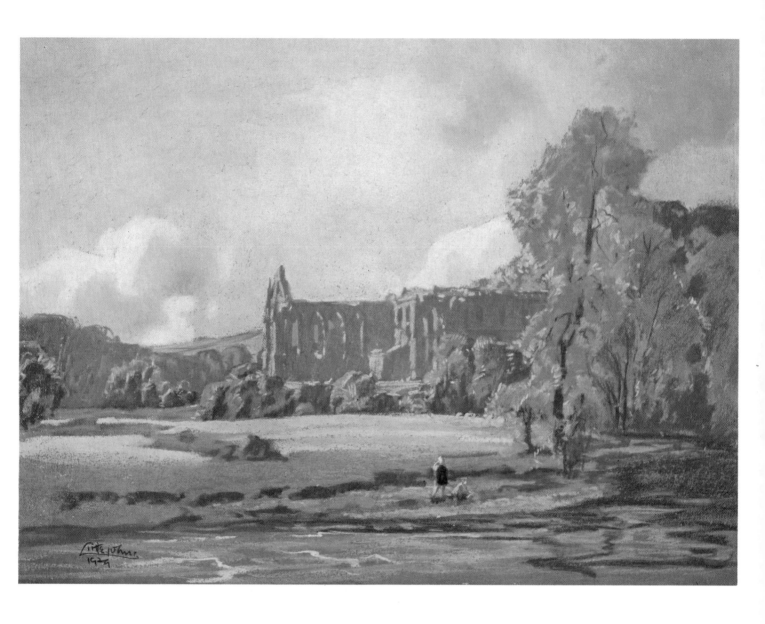

Plate XL. BOLTON ABBEY. *The picture was painted on a cool, cloudy day with soft lights and indefinite shadows. The paper chosen was warm brownish gray, slightly lighter than the building—a color which shows through the shaded parts of many of the trees and most of the foreground. But, as the warm color and low tone of the paper disagreed with the cold color and pale tone of the sky, the whole surface was rubbed in with varied grays. Next, the darkest passages were laid on flat with dark warm grays, excepting details, such as treetrunks and ripples. Then all the trees and grass in shade were painted with varied grays and grayish greens. The actual color of each pastel was rather brighter than appeared after painting, because each was lightly applied and so modified by the warm grayness of the paper. This done, the building was found to*
be too light. The whole surface was covered with rather dark gray applied with the side of the pastel, loosely, so as to suggest crumbling age. The water in the foreground was found to be about the same tone as the building, but colder, and was covered with rather dark bluish gray pastel. The picture was then developed by many sharp touches of cold lights, on the trees, warm lights on the building and bank, long strokes of warm green in the grass, and almost white lights on the clouds and water. When this was done, almost all that remained were the dark lines for the treetrunks and branches, ripples in the water, shadows on the bank, and touches on the masses of smaller trees. A few touches of cold gray defining the windows, and a suggestion of figures in the foreground completed the picture.

79

Plate XLI. PRELIMINARY NOTE OF CONSTRUCTION FOR
BEN VENUE (PLATE XLIII). *The first impression created by
this type of subject on the uninitiated student is one of over-
powering difficulty. Regarded calmly for a little while it re-
solves itself into a series of quite simple masses distinguished
by well-separated tones, broken by many brilliant lights and
breaks in the contours. Before beginning the sketch it is essen-
tial to see the whole in a simplified form—i.e., to realize the
underlying structure and arrangement. In this sketch, the lines
show by means of large simple curves the basis of the arrange-
ment. These need not be drawn with the pencil, but with the
mind. When defining the great rugged masses, as shown in
Plate XLII, the underlying forms should be continually borne
in mind to keep the lines of the sketch within bounds. With
practice, the student will tend to simplify forms and the parts
in the interest of a unified arrangement.*

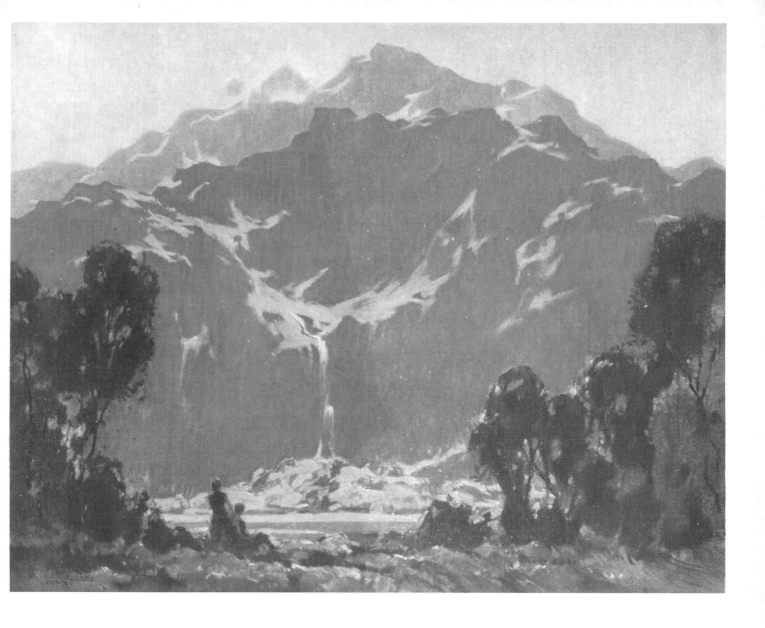

◁ *Plate XLII.* Preliminary Note of Tones for Ben Venue (Plate XLIII). *This second stage is directed to the consideration of tones—that is, the lightness or darkness of each mass compared with the other masses. In this example it will soon be seen that there are four main divisions of tone: (1) the sky, (2) the distant mountain, (3) the nearer mountain, and (4) the trees. Stated in percentages, calling white 0 and black 100, the proportions are about thus: sky, 10; distant mountain, 15; nearer mountain, 30; trees, 80. Slight differences in each separate tone are ignored. The paper chosen was, naturally, exactly the tone of the largest mass (the nearer mountain), so that it could be left untouched except for the lights. The foreground is about the same tone as the nearer mountain. By this process, the whole tonal arrangement has been simplified.*

△
Plate XLIII. Ben Venue. *Now that the student has gained a firm grip of all the fundamentals of form, tone, and arrangement, the painting of this subject should have been reduced to comparative simplicity. Before commencing to paint, note the main differences in color. The sky is grayish pink, the distant mountain is grayish blue, and the nearer mountain is warm gray. The trees are very dark and very warm reddish gray. The lights on the mountains are in two tones of grayish pink. The lights on the opposite shore are very pale yellow and pale yellow-orange. The underlying color of the foreground is reddish gray-brown. Select the pastels which most nearly correspond to these colors when laid firmly on to the paper and use the side of the pastel, or slightly rub in. Paint each color practically flat, leaving out all the lights except the sky. Vary the tone of the distant mountain, making it slightly lighter at the sides. Go over the nearer mountain with upright strokes of greenish gray, very softly, and rub in slightly if these lines are too insistent. A few fainter lines on the distant mountain will also help to give an effect of distance and of great height. The remainder should need no description, as it consists mainly of sharp touches of color, which are seen in the illustration.*

Plate XLIV. Autumn—Ely (First Stage). *No one could fail to see that brown paper is best fitted for this subject. By choosing a paper exactly the color of the ground and brown trees in shadow, at least one-third of the paper could be left untouched. But, for a finished picture(which would need to be rather larger than usual in order to paint the figures with sufficient exactness) one or two other browns will be needed to give a little variety to such a large surface. And in the near trees are two darker browns, one repeated on the ground, and the other on the nearest tree trunk and the large doorway. Most of the lights are rich, pale browns. Grayed blue-violet,*

painted so as to allow some of the paper to show through, will serve for the background of buildings into which the brown trees will appear to melt. The untouched parts of the near trees, including the trunks as well as the sky, can be painted with varieties of green, dark greens lightly applied to the trunks, more strongly applied to the greener leaves, and light grayish greens for the sky. This plate shows the beginning of the first stage, where most of the surface is covered by browns and dark grays. It needs to be carried farther in order to be ready for the final sharp touches of bright lights and definite darks which will give it the crispness that it lacks in this stage.

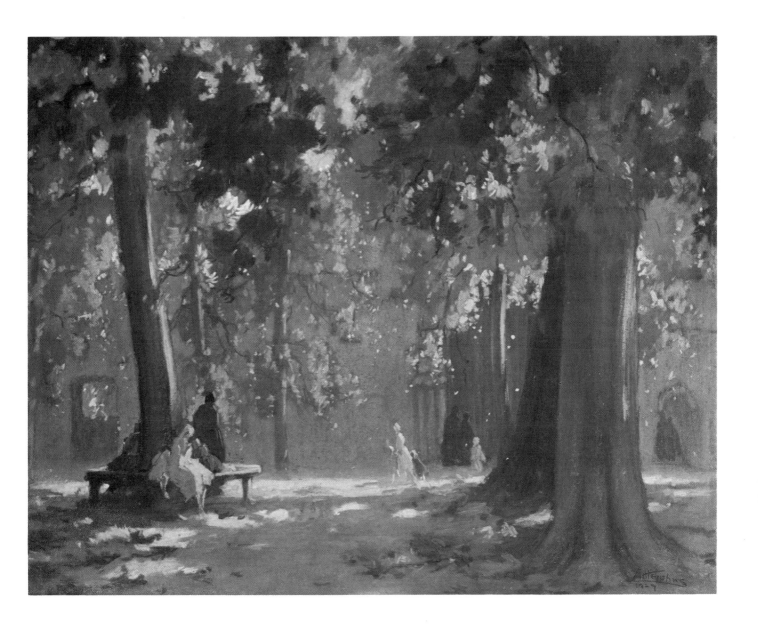

Plate XLV. Autumn—Ely (Second Stage). *The transformation effected by a few deftly painted touches of pale, warm colors is a striking evidence of the suitability of the subject for treatment in pastel, and of the method employed. An immense quantity of detail is suggested with the minimum of effort—an effect of brilliance and movement that could not be expressed with the same speed and ease in any other medium. The picture, which was painted on a much larger scale than the reproduction, with large strokes, shows every touch ap-*

plied and needs no detailed description. The darkest of the lights should be painted first, ending with the palest yellowish orange touches on the leaves, ground, and figures. If this picture were painted on a rather small scale, it might be advisable to rub in the whole of the first stage, providing the rubbing was done very lightly, so that some of the paper showed through. But any suggestion of pervading, even smoothness would be disastrous to a subject expressive of multitudinous moving details.

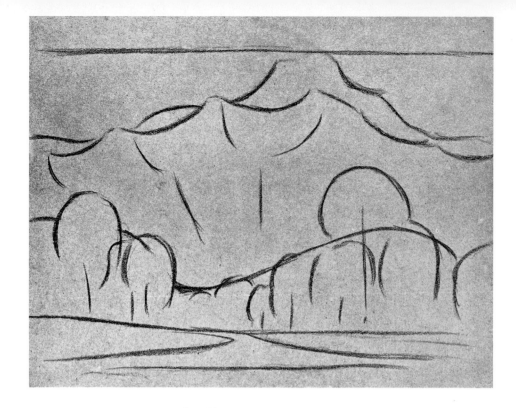

Plate XLVI. Preliminary Note of Construction for The Trossachs (Plate L). *As this is a much more elaborate picture, in drawing, color, and composition, two stages of a preliminary drawing are shown. In making this first preliminary note, attention was first directed to the design. Notice the undulating rhythmic "lines" which are the basis of the arrangement. The sensitive artist feels rather than sees them, and does not need to express the movements in actual lines, but they exist as a sort of mental skeleton.*

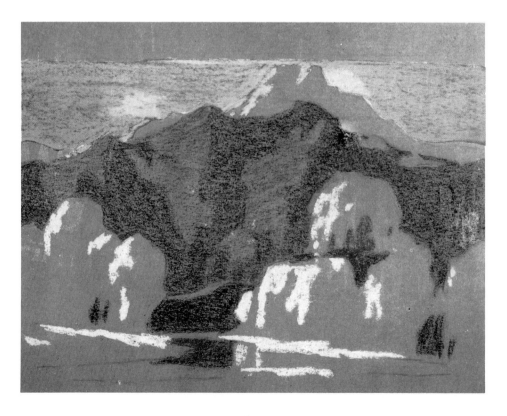

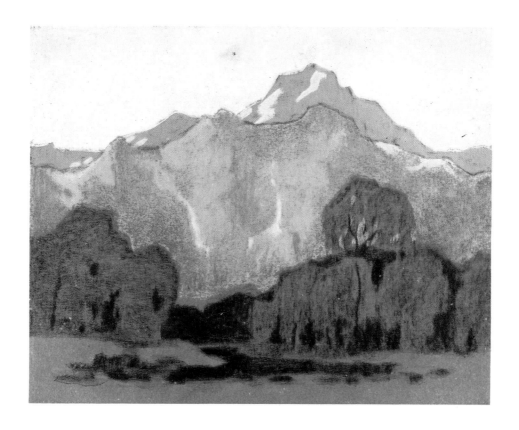

◀ *Plate XLVII.* PRELIMINARY NOTE OF TONES FOR THE TROSSACHS (PLATE L). *This note shows the main forms and the relative tones as they were drawn before completing the details. Several experimental notes were made before the final arrangement was settled. For, to attempt to paint the final picture in pastel before coming to definite conclusions about the design would be to invite almost certain failure. The actual subject, as seen in nature, did not take by any means the ordered arrangement seen in the picture. But the effect happened for a few minutes. The nearer mountain was enveloped in shadow, while a belt of paler shadow lay across the foreground and a pale gray cloud hovered over the distant mountain. A bar of light flashed across the trees and banks, with a lesser light on the distant mountain and clouds. This suggested the tonal aspect of the composition.*

△
Plate XLVIII. A VARIATION CAUSED BY LIGHT EFFECTS IN THE PRELIMINARY SKETCH FOR THE TROSSACHS (PLATE L). *The pictorial possibilities of most subjects are not limited to one view, or to one arrangement of light and shade, or to one color scheme. The Trossachs (Plate L) is an example of a subject which, without altering the forms, might be painted with equal success in several varieties of lighting. On a day with quickly moving clouds, a dozen transformations may take place in as many minutes. This plate is an example. The whole appearance has been changed solely because the horizontal cloud at the top of the picture, which shadowed the middle distance, has moved forward and darkened the foreground and trees, leaving the rest in brilliant light. Arrangements of light and shade, due to such accidental causes, could seldom be expected to form ready-made pictures, but they are generally full of happy suggestions. The accomplished pastellist is always waiting to take advantage of them as they happen, by making swift notes. It would be well, when in front of scenes such as this, to prepare a few drawings of the basic composition of the landscape before you in charcoal during a lull in striking effects, so as to be able to set down in a few strokes any inspiring arrangement before it disappeared.*

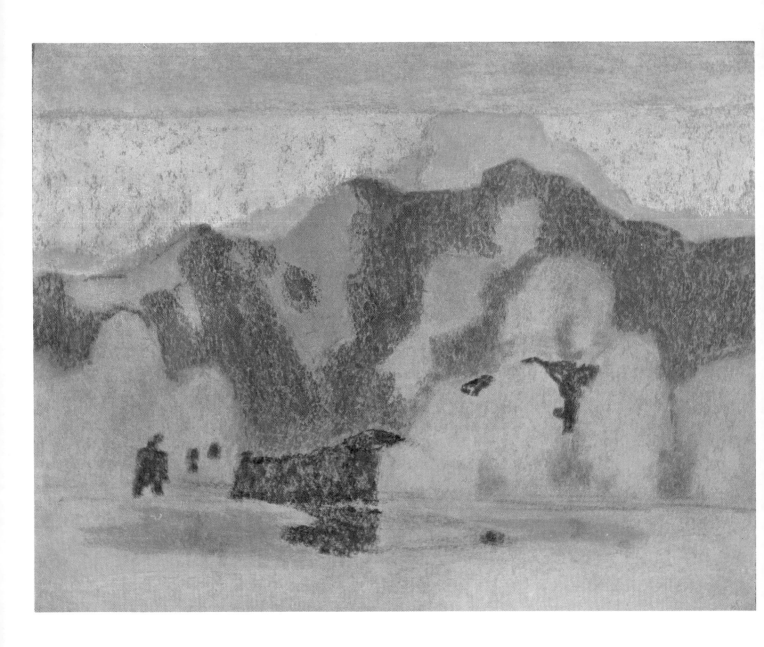

Plate XLIX. The Trossachs (First Stage). *The color scheme was not based on any view of this scene, as the district was visited when the trees were green! Autumn sketches of similar trees served to make good this deficiency. The choice of paper for this subject required careful thought. Gray-brown suits the color of the trees in shadow and the foreground, but would have to be completely obliterated over most of the remainder of the picture, either by using much pressure or by rubbing in. In subjects such as this, where large portions are of colors contrasting to other parts, no one paper can be distinctly more suitable than all others. The paper chosen was about the color of the horizontal cloud. With a little of the paper showing through, light blue comes near to representing the sky, and slightly darker blue the distant mountain. Gray-brown and dark warm blue serve for the mountain in the middle distance, yellowish brown for the shadows of the lighter trees and the foreground in shadow. In every case, the necessary color is obtained by the modifying effect of the gray paper. This plate shows the first stage partially completed, i.e., before any part has been rubbed in. Almost every part except the cloud will need to be slightly darker, which effect, in some cases, can be accomplished by rubbing.*

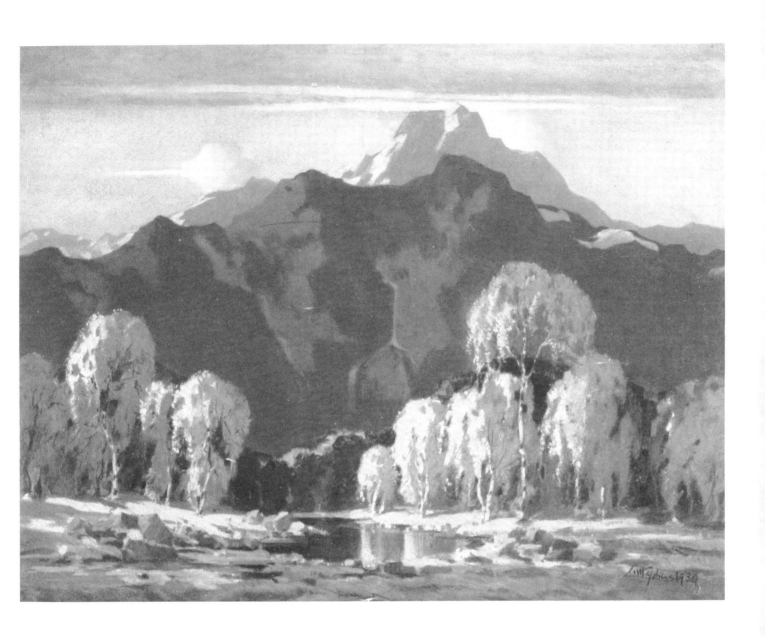

Plate L. THE TROSSACHS (SECOND STAGE). *There is nothing in the painting of a pastel that gives such a sense of easy mastery as the few strokes which can turn a mass of formless smudges into decisive and purposeful definition. Subjects which are, for the most part, low in tone, emphasized and clarified by a few sharp touches of lights and darks, lend themselves most readily to treatment in pastel. But the method is not quite so simple as may at first appear, for three reasons: (1) It is not always possible to preserve the original drawing when painting the first stage, so the second stage may have to be painted without the aid of the charcoal outlines with which* the picture began. (2) The introduction of strong lights into a picture makes all the rest look darker, and the introduction of decided darks has the opposite effect. These changes have to be borne in mind. In the present case, most of the second stage is composed of brilliant lights, and there is always a danger that the beginner may make the first stage too dark. (3) The introduction of any bright color tends to make the rest appear somewhat of the opposite color, and rather dull. In this example, the yellow lights tend to make the middle distance darker, duller, and more violet. The extent of these changes can never be estimated correctly except by experience.*

Plate LI. Line Analysis of The Quantock Hills, Somerset (Plate LIV). This diagrammatic charcoal outline *represents the first stage of a compositional analysis of the pastel landscape in Plate LIV.*

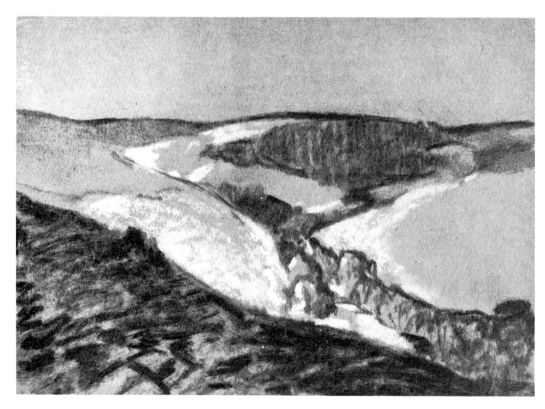

Plate LII. Study for The Quantock Hills, Somerset (Plate LIV). *In this charcoal drawing, the pattern of the landscape is clearly demonstrated. This result was arrived at by deliberately emphasizing the design as well as by a decisive rendering of contrasting light and shadow, so that no doubt is left as to the general principles relating to the structure of the finished picture.*

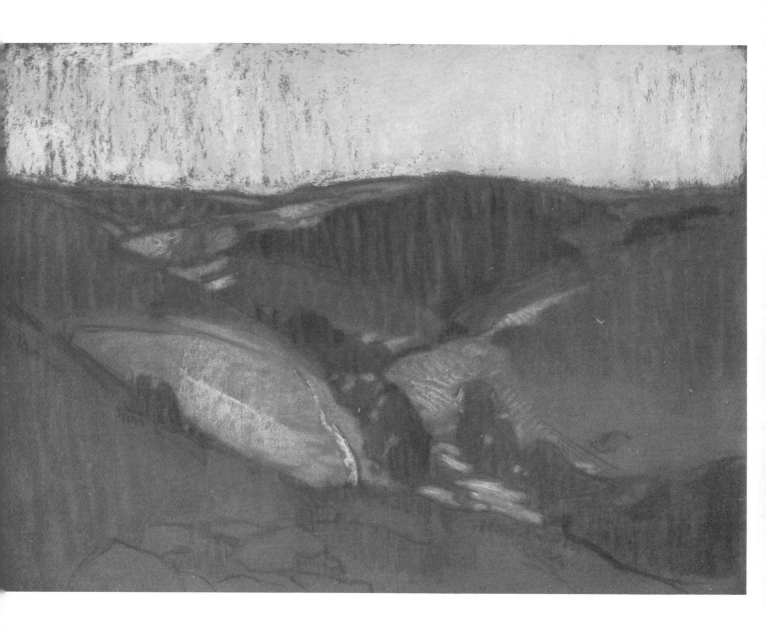

Plate LIII. THE QUANTOCK HILLS, SOMERSET (FIRST STAGE). *Dark gray—the color of the paper on which the first stage was completed—blended excellently with ultramarine blue, burnt umber, and russet green, as depicted in this plate. Two shades of yellow ochre, followed by touches of light silver gray, were used for certain portions of the sky, while burnt sienna completed the color scheme of the foreground. The deep tone of the paper was left untouched in places, so as to assist in uniting the various conflicting colors that spread over the picture. See Plates LI and LII for analytical drawings relating to this subject.*

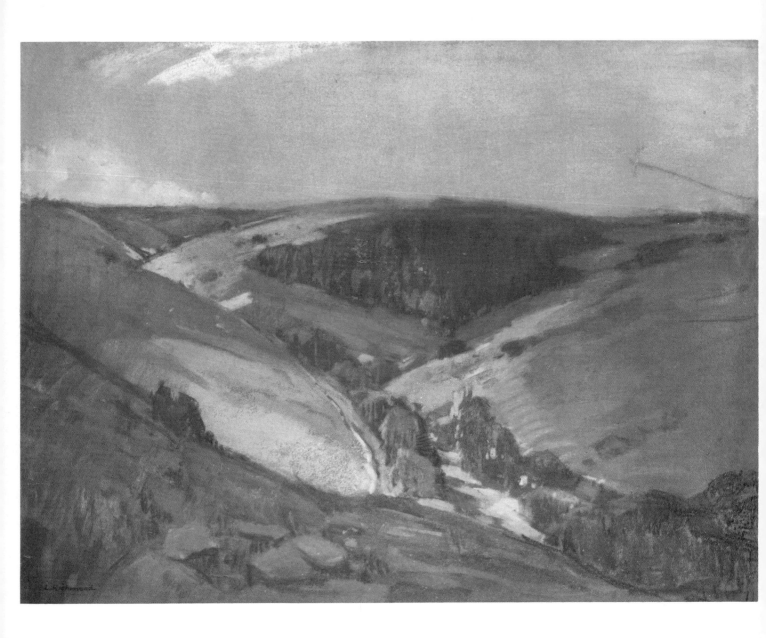

Plate LIV. THE QUANTOCK HILLS, SOMERSET (SECOND STAGE). *Dark gray and olive green were carefully spread over the decided blue-tinted distance. These two colors were lightly applied so as to leave some visible evidence of the original blue below. For outdoor landscape sketching a large assortment of cool and warm tinted grays—ranging from light to dark—is indispensable if correct tones are sought for. Gray, spread over the surface of any violent color, will immediately reduce the offending tint to a pleasing harmony. See Chapter Six for detailed information.*

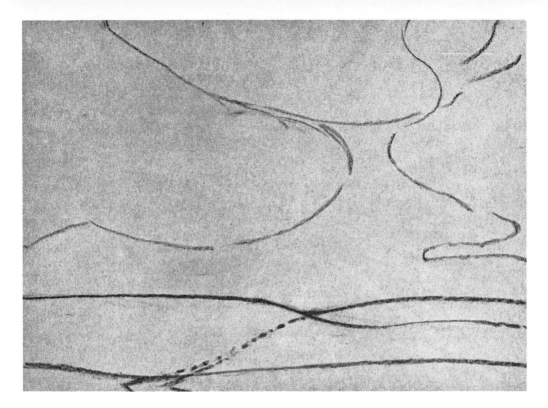

Plate LV. Line Analysis of Study of Clouds (Plate LVIII). *The leading lines in the sky denote approximately the position of the numerous clouds in the finished picture.*

Plate LVI. Study for Study of Clouds (Plate LVIII). *This study suggests the composition as well as the effect of the light clouds contrasting with a dark background.*

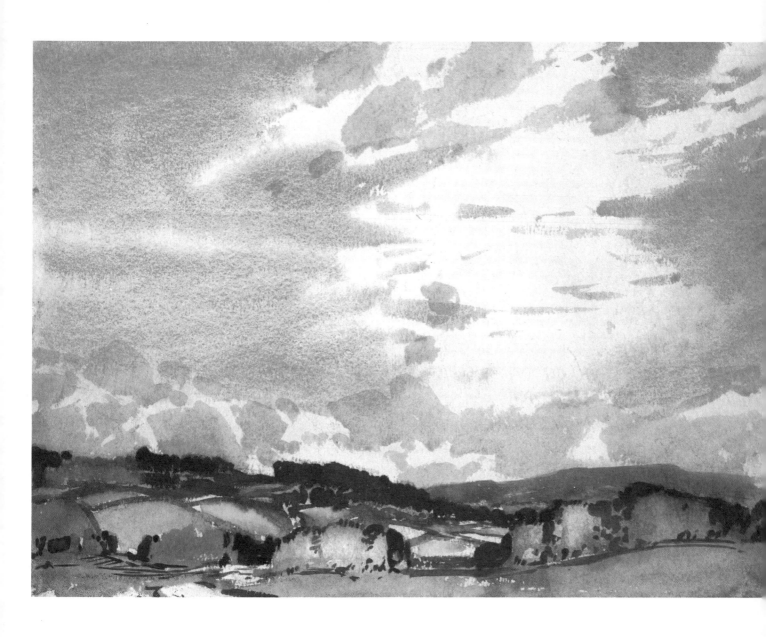

Plate LVII. STUDY OF CLOUDS (FIRST STAGE). *The adjoining watercolor study was unsatisfactory, since it failed to give enough information relating to the drawing and pattern of the clouds; although the various accessories displayed in the landscape conveyed all that was required. The subject was painted on David Cox buff-tinted paper, a paper which demands simplicity of handling, as no drastic alterations can be made after a color wash has been laid on.*

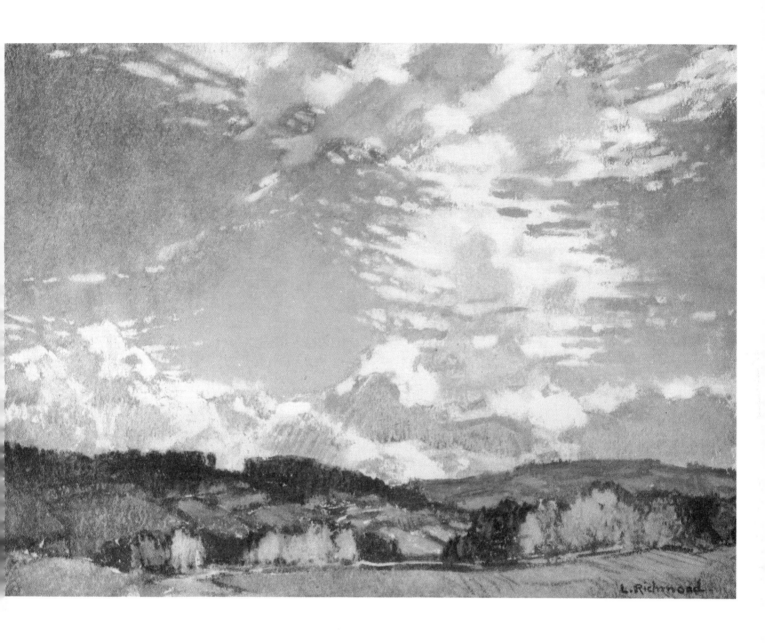

Plate LVIII. STUDY OF CLOUDS (SECOND STAGE). *The watercolor failure shown in the previous plate is now greatly improved with the aid of pastels over the delightful surface of David Cox paper. The various colors and tones made in the original watercolor painting helped considerably as a foundation on which to build the necessary pastel touches. The problem would have been more severe without the help of preparatory watercolor tints. As this plate clearly demonstrates, the value of pastels cannot be over-estimated as a medium in which drawing, color, and tone are made simultaneously with a consequent saving of valuable time.*

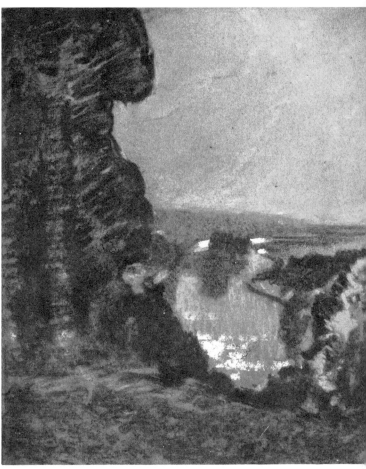

Plate LIX. LINE ANALYSIS OF THE THAMES, NEAR MAIDEN-HEAD (PLATE LXII). *The Thames near Maidenhead makes an excellent upright composition, chiefly owing to the stately height of the trees towering up on the left side of the picture. The continuity of line relating to these trees makes a rather unusual shape as seen in this plate. The pathway in the foreground on the left assists in bringing the eye towards the river in the middle distance.*

Plate LX. STUDY FOR THE THAMES, NEAR MAIDENHEAD (PLATE LXII). *The pattern of the subject was severely adhered to by leaving out the clouds, thus giving greater value to the sparkling light on the river and the dark silhouette of the foreground trees.*

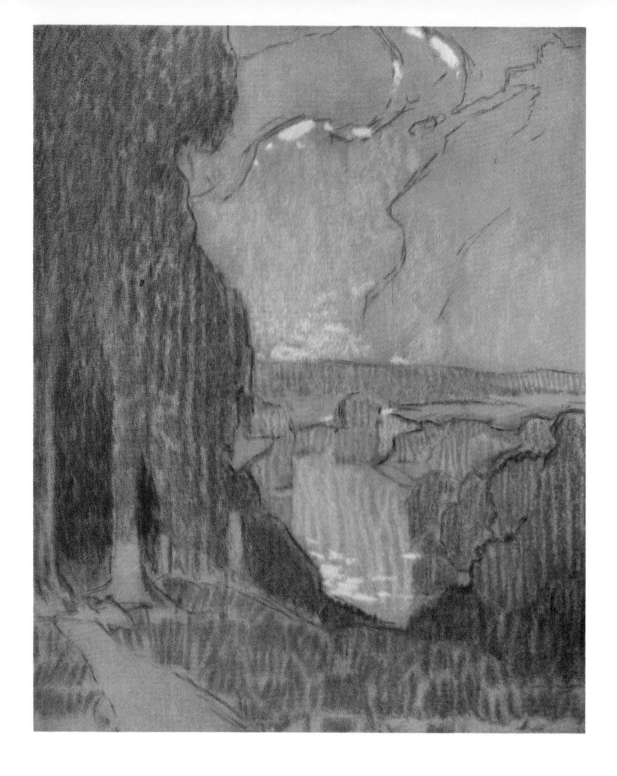

Plate LXI. THE THAMES, NEAR MAIDENHEAD (FIRST STAGE). *This subject makes an interesting composition, chiefly owing to the solid foreground and the tall trees on the left side. Plates LIX and LX suggest the main features of the pictorial pattern both in line and mass. In Plate LX, the clouds were purposely left out so that the general design of the pic-ture could be more easily understood. A preliminary outline was made with charcoal before using any pastels. The color of the paper is easily seen at the top of the picture. Two shades of yellow ochre, ultramarine blue, burnt sienna, purple-gray, and ivory black proved sufficient for the coloring of the first stage.*

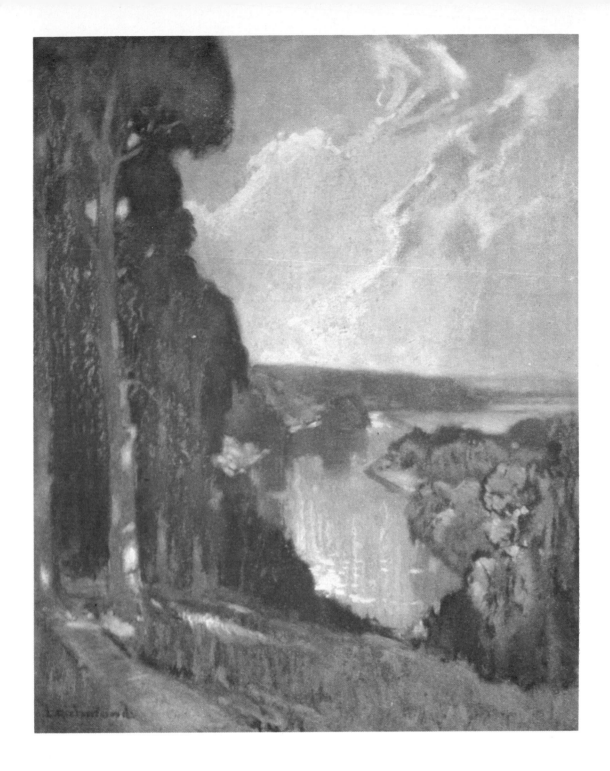

Plate LXII. THE THAMES, NEAR MAIDENHEAD (SECOND STAGE). *The tall trees on the left were deepened in tone with ivory black and dark brown before introducing the final touches of deep Hooker's green and dark purple-gray. Russet green and light yellow ochre helped in getting the lighting effect of the trees situated on the right of the foreground. No difficulty was experienced in changing the yellow-tinted river seen in the first stage into a more normal color by the adroit use of cerulean blue—white and light yellow ochre mingled well with cerulean blue at the lower end of the river. Dark gray was used extensively for the distant trees over the original blue ground. The reproduction shows the other colors.*

Plate LXIII. Line Analysis of Le Portal, Pas-de-Calais (Plate LXV). *The dotted lines suggest various converging lines caused by the arrangement of bathing tents and figures grouped along the beach. The other curves denote the positions of the foreground and middle distance.*

Plate LXIV. Study for Le Portal, Pas-de-Calais (Plate LXV). *This study gives a clear effect of light versus shadow. The dark-toned foreground, rising from the left to the top of the picture on the right, makes an excellent foundation—or support—to the lighter-toned material behind.*

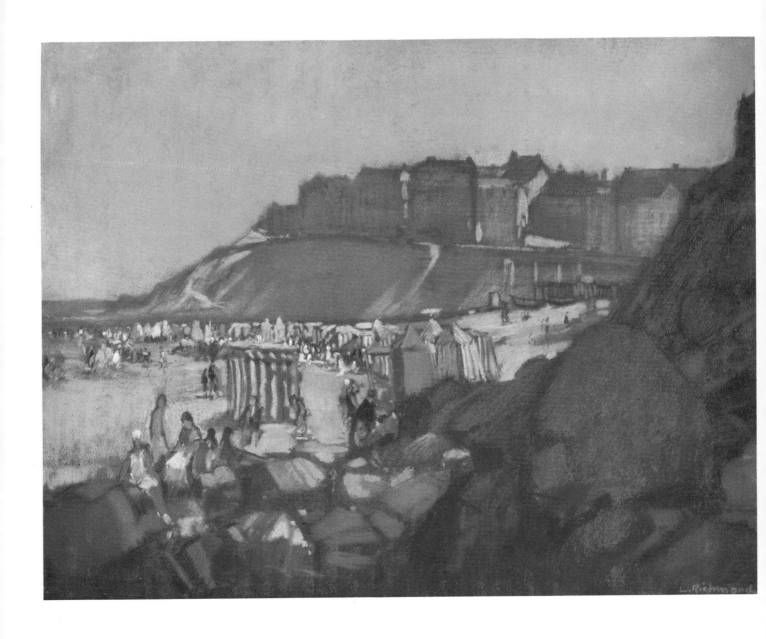

Plate LXV. LE PORTAL, PAS-DE-CALAIS. *The dark-toned foreground was originally covered with deep brown, and ivory black was used to indicate the drawing of the broken rocks, etc., at the foot of the picture. A certain amount of light gray was added to the yellow ochre so as to set an outdoor atmosphere. Yellow ochre alone generally lacks refinement on dark-tinted paper. The various groups of figures dotted along the shore were suggested with rapid pastel touches without any striving to get correct drawing. Notice the silhouette effect of the brightly-colored tents in the distance against the dark flat-toned material behind. The whole of the study was made outdoors in one sitting, in accordance with the same principles of pastel technique already advocated in this book. See Chapter Six for further information.*

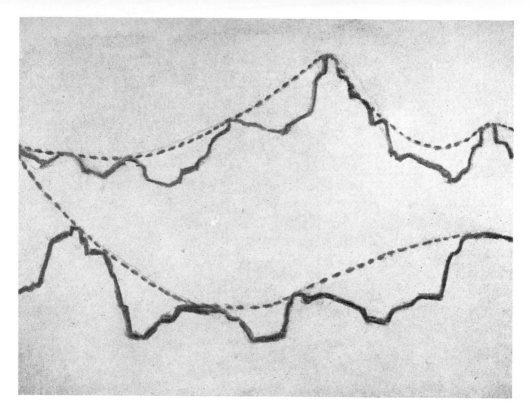

Plate LXVI. LINE ANALYSIS OF THE DOLOMITES (PLATE LXVIII). *The dotted lines show how the various mountain peaks are connected in the preliminary charcoal study for* The Dolomites *illustrated in Plate LXVII.*

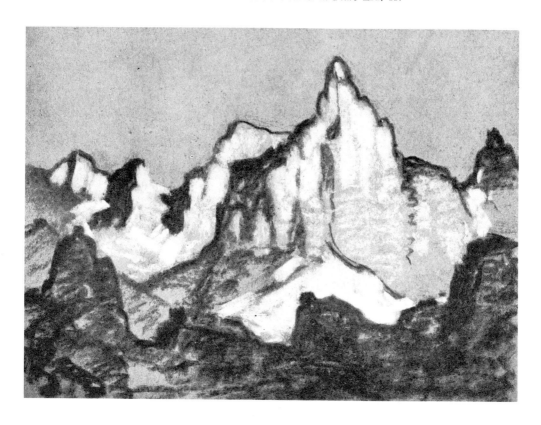

Plate LXVII. STUDY FOR THE DOLOMITES (PLATE LXVIII). *In this charcoal drawing of* The Dolomites *it does not, at first glance, seem possible that a series of flowing curves could connect up the various mountain peaks shown in the picture, but the analysis of line in Plate LXVI demonstrates how it is done.*

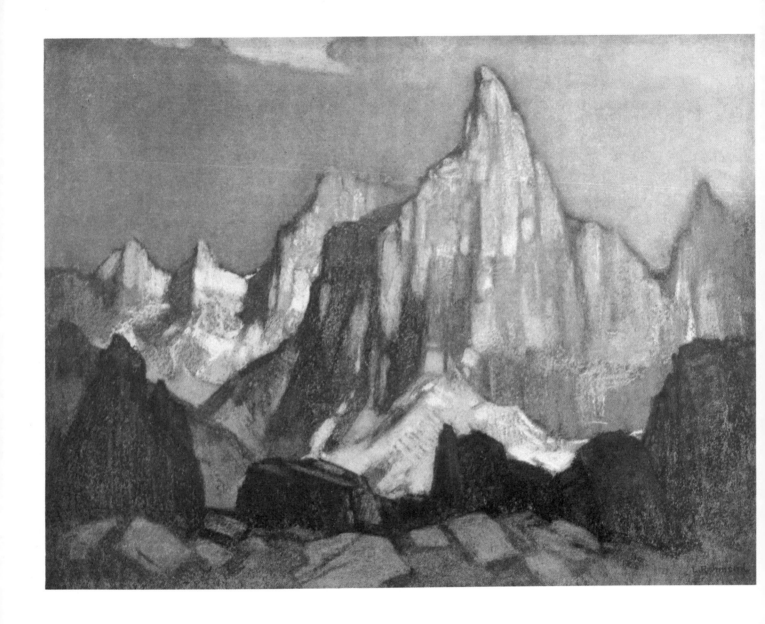

Plate LXVIII. THE DOLOMITES. *The tint of the paper on which this subject was painted is rather dark brown. The color of the dark, rugged foreground was made with ivory black, burnt umber, dark gray, and burnt sienna. Most of the ground colors in the rising peaks are of a bright nature, so that the various final surface touches of silver and purple-gray were pleasantly affected by their brilliancy, without losing the har-* *monious charm so characteristic of gray pastels. A considerable amount of gray was also introduced in the cobalt blue sky. The lightest of yellow ochre for the sunlit portions on the left side of the mountains, also chrome and orange chrome for the secondary lights in the same locality, gave a valuable contrast to the more sober color scheme extending towards the right of the picture. See Chapter Six for further information.*

Plate LXIX. Line Analysis of Portrait of Mrs. T. R. Badger (Plate LXXII). *This charcoal line drawing shows the general setting of the figure in relation to the size of the paper on which it is placed. It is drawn in the same proportion as the original pastel in Plate LXXII.*

Plate LXX. Study for Portrait of Mrs. T. R. Badger (Plate LXXII). *A certain amount of tone has been added by rubbing in the charcoal, followed by touches of white chalk, so as to convey the position or locality of the highlights on the face and costume. The touches of white chalk make a valuable reference in case of lighting difficulties, during the painting of the portrait.*

Plate LXXI. PORTRAIT OF MRS. T. R. BADGER (FIRST STAGE). *It is very important in pastel portrait painting to get a correct line drawing before attempting any color effects. Charcoal was used for the preliminary drawing in the first* *stage. The light and shadow seen on the face were made with two colors only—light and dark burnt sienna. These two tints can be seen on the right at the foot of the reproduction. The gray paper cools the intensity of the two burnt sienna colors.*

Plate LXXII. PORTRAIT OF MRS. T. R. BADGER (SECOND STAGE). *For the finished study of this picture additional colors became involved, but the various tones had to be kept constantly in mind during the application of more pastel colors. The heightened tints of the face, that were worked on top and* between the burnt sienna ground (already dealt with in Plate LXXI), consisted of yellow ochre, which blended well with light, cool gray, in addition to a delicate touch of carmine and light red on the cheek. Charcoal was invaluable for the shadows of the eyes and forehead, with the aid of local color.

Plate LXXIII. LINE ANALYSIS OF MARKET DAY, DIEPPE, FRANCE (PLATE LXXVI). *This analytical drawing is somewhat unusual when judged from the conventional standards of pictorial composition.*

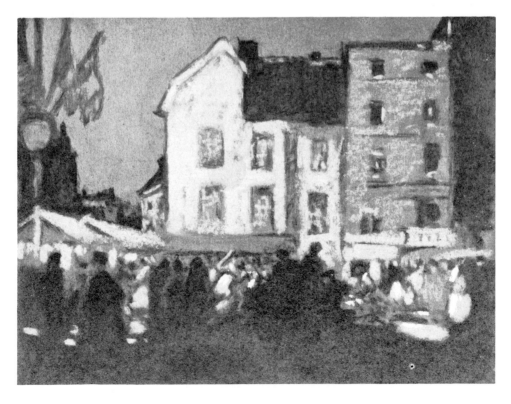

Plate LXXIV. STUDY FOR MARKET DAY, DIEPPE, FRANCE (PLATE LXXVI). *The simple planning of the subject should be self-explanatory in this charcoal and chalk drawing.*

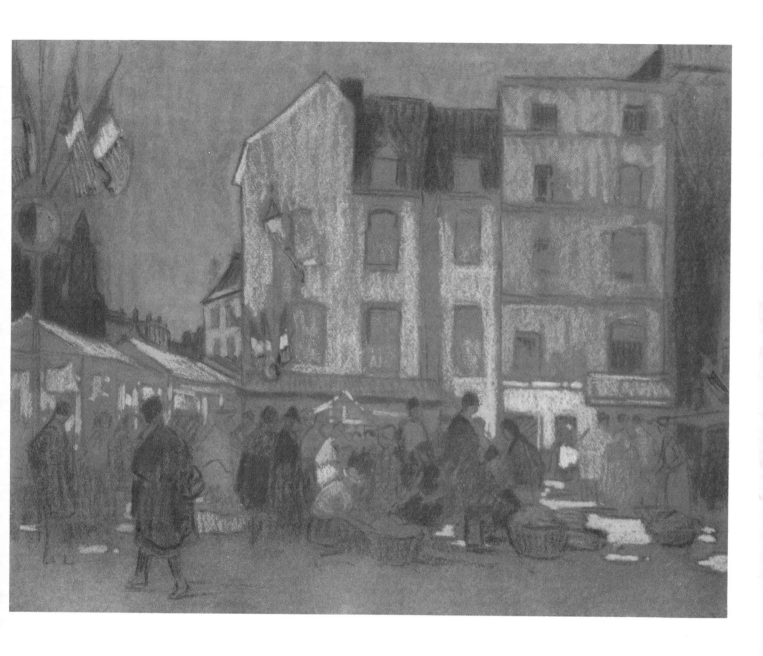

Plate LXXV. MARKET DAY, DIEPPE, FRANCE (FIRST STAGE). *Some caution was necessary in this first stage of the market scene so as to get a desirable suggestion of a coherent design on the dark but cool brown paper. The crumbling effect noticeable on the central building was made with one color only—yellow ochre. The red tint of the adjoining building on the right was obtained with a bright crimson pastel, but ex-* *amination of the reproduction will reveal how little the brilliancy of this color has affected the tone of the dark paper below. In order to achieve this result the bright crimson pastel was, of course, very delicately applied to the paper. The whole of this stage is treated with light tentative pastel touches so as to suggest—rather than actually state—the general color scheme of the subject.*

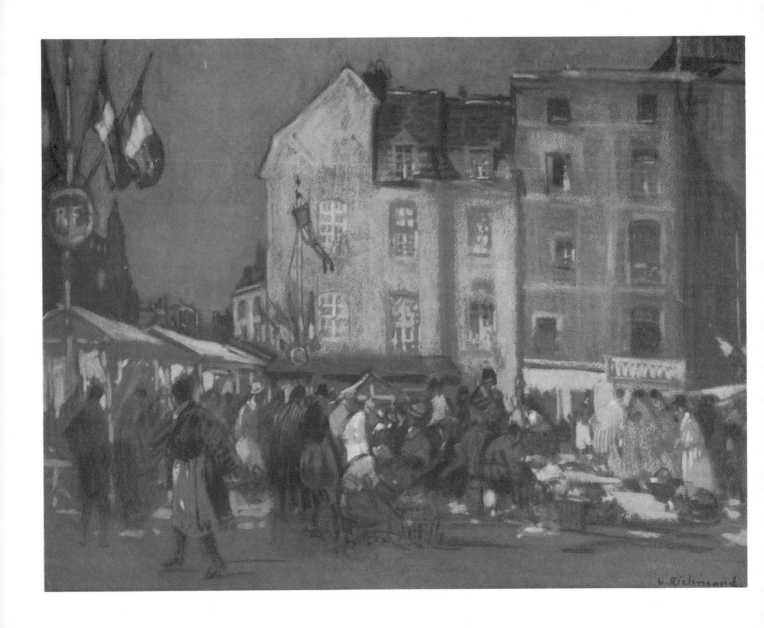

Plate LXXVI. MARKET DAY, DIEPPE, FRANCE (SECOND STAGE). *When the first stage is correctly spaced in relation to the general composition of a subject the final pastel touches give very little trouble to the artist, since each state of the pastel is allocated to its proper position. The above remarks can be aptly applied to the finishing stages of the Dieppe market scene illustrated here. The crimson-colored building de-* *picted in the first stage was reinforced with orange chrome and gray, while the central building was solidified with judicious touches of light yellow ochre, but without entirely covering the cool brown paper below. Intense black strengthened the foreground figures and white, lemon yellow, light yellow ochre, emerald green, etc., were brought into play for emphasizing the brilliancy of figures in sunlight.*

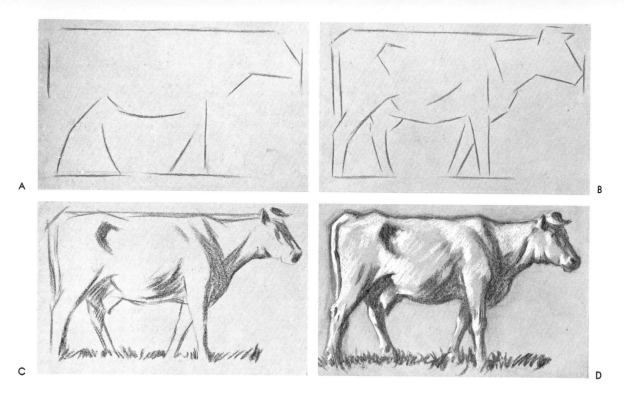

Plate LXXVII. Study of a Cow in Black and White
Chalks on Gray Paper. *Above is a study of a cow, executed
in black and white chalks on medium gray paper, and shown
in four stages. Stage A determines the main proportions and
lines governing the form. Most of the lines are made straight
so that the angular character of the animal can be emphasized
from the beginning of the study. Stage B modifies the lines in*
the first stage by secondary lines, particularly within the out-
lines. Stages A and B are drawn with charcoal and then dusted
off. Stage C completes the lines, and indicates the main pas-
sages of light and shade in black chalk. Stage D completes the
drawing with white and black chalk. In Plates LXXVIII and
LXXIX the same cow is shown in two stages executed in
pastel.*

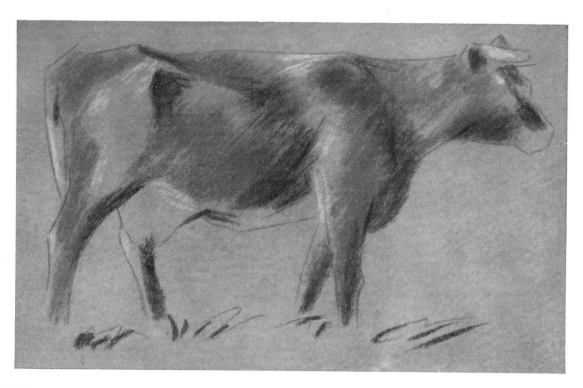

Plate LXXVIII. Study of a Cow in Pastel (First
Stage). *After carrying the drawing through with charcoal,
paint the darker of the local colors with a few touches indicat-*
*ing the lights. Apply the pastels rather lightly in every part to
give a rather rough surface, and to allow the paper to modify
the colors.*

107

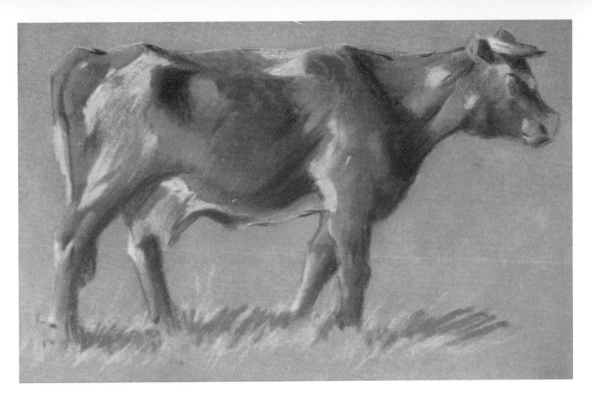

Plate LXXIX. STUDY OF A COW IN PASTEL (SECOND STAGE). *In this stage, use pale brown for the lights on the darker parts, pale gray and pale cream on the lighter parts, and a few strong touches of black for the darker shadows and for occasional emphasis of form.*

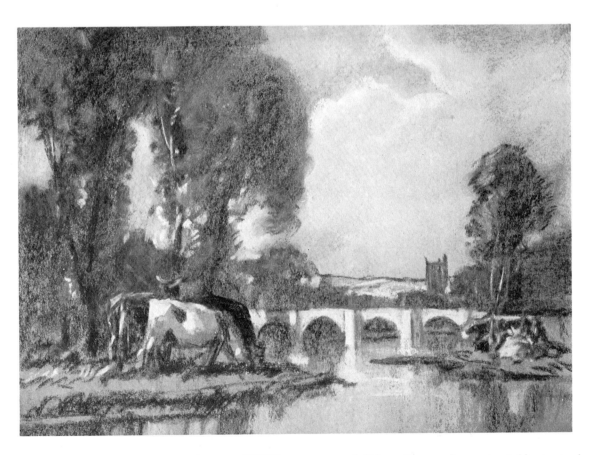

Plate LXXX. STUDY FOR A PASTORAL (PLATE LXXXI). *In this preliminary study in black and white drawn with black and white chalks on medium gray paper, the main objects were (1). to determine the composition, (2) to settle the tones, and (3) to discover the most suitable size to draw the animals. The animals are seen to be too large. They stand out too prominently, instead of taking their places as strong incidents in the whole composition.*

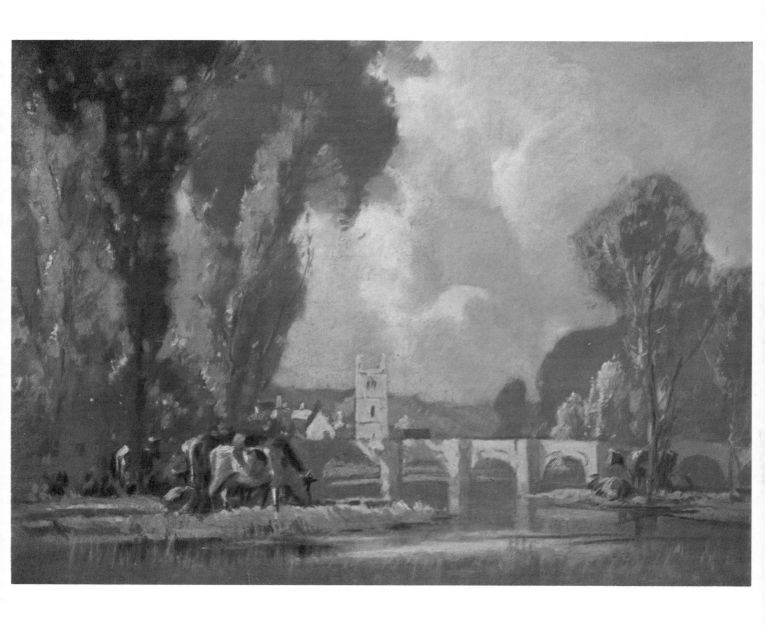

Plate LXXXI. A Pastoral. *Here, the fault that appeared in Plate LXXX has been corrected. The animals give additional life and interest, and serve as a focus of bright color. The picture is slightly rubbed in over most parts. It will be noted that the church now takes a more prominent place in the composition. Being strongly lit, and placed nearer the animals, it reduces the prominence of the cows. It also serves as a balancing point for the whole design.*

A

B

C

D

Plate LXXXII. A Group of Sheep in Halftone on Gray Paper. *This is a simple method of drawing a small group of sheep, shown in four stages. Stage A determines the proportions and the directions of the main lines. Stage B indicates the characteristic forms and the main passages of shade. These two stages are drawn with charcoal. Stage C completes the drawing in black chalk, and Stage D completes the light and shade. A considerable amount of paper is left untouched.*

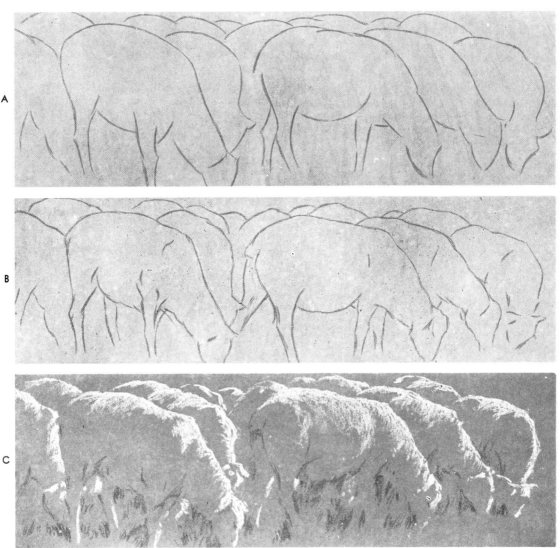

A

B

C

Plate LXXXIII. Part of a Flock in Halftone on Gray Paper. *This plate shows a portion of a flock of sheep shown in three stages. Stages A and B are drawn in the same way as Stages A and B of Plate LXXXII. But the final stage (C) is less detailed. It will be found that, as a rule, the larger* the number of sheep in the flock the less detailed shading will be needed for each. Otherwise too much attention will be directed to individual sheep and the massiveness of the whole flock will be lost. A parallel case is the painting of a wood: too much emphatic detail should not be lavished on each tree.*

110

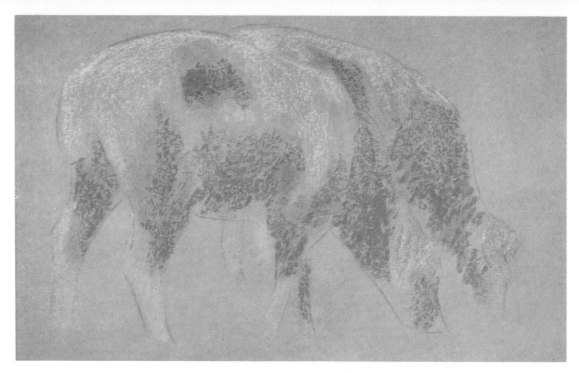

Plate LXXXIV. A STUDY OF SHEEP (FIRST STAGE). *This first stage defines the broad masses of light and shade. The two pastels used are roughly applied, leaving the halftones untouched. The whole study could be completed by strengthening these two colors until the required variety of tones was obtained.*

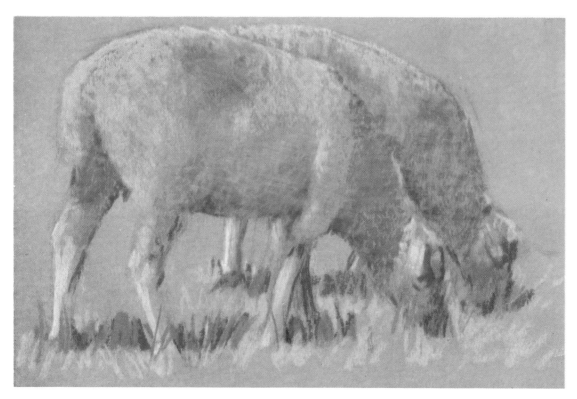

Plate LXXXV. A STUDY OF SHEEP (SECOND STAGE). *The second illustration is not really a continuation of the one in Plate LXXXIV. It is the second stage of a study in which the first stage was treated rather differently. A warm tone was first rubbed in over most of the surface. As the reproductions show every stroke of the pastels, there is no need to give further detailed directions. When a large number of sheep have to be suggested, if not drawn in great detail, when painting a flock, it is necessary to be able to draw the animal in many positions from memory. For it would be tiresome to have to make separate studies of every sheep differing in form and position from the others. Assiduous memory drawing is the only satisfactory preparation. For although the positions and actions of many of the sheep in a flock may appear at first to be precisely the same, actually there are subtle differences which give interest to the whole composition.*

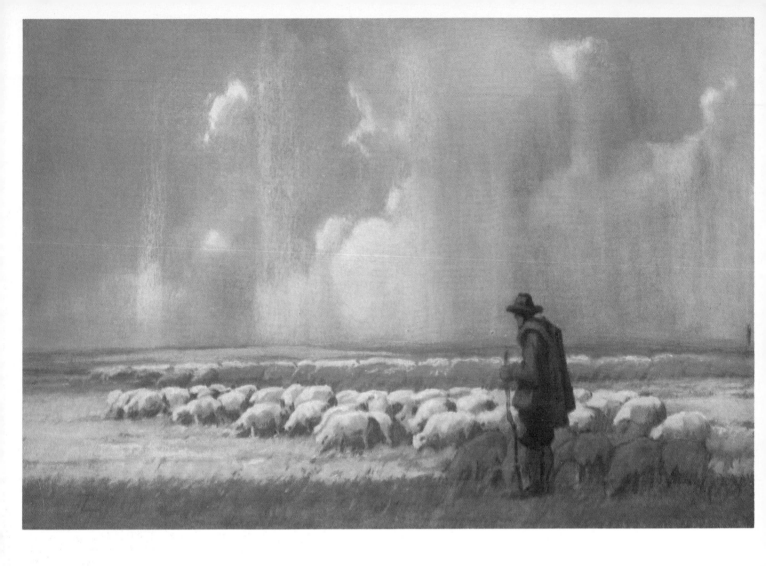

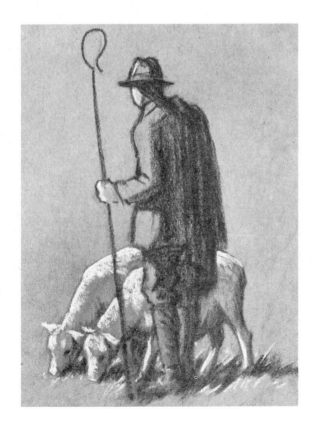

Plate LXXXVII. A SOUTH DOWNS FLOCK. *As the figure (see the figure study in Plate LXXXVI) is the most prominent spot in the picture, and nearest to the spectator, a fair amount of detail is needed, but not enough to take interest from the rest by the picture. Few details in a picture can be so offensive as a badly drawn or clumsily suggested figure, because mistakes are generally more easily recognized. Photographs of shepherds may contain valuable suggestions for effective poses. These might well be consulted, but not, of course, in order to make copies.*

Plate LXXXVI. STUDY FOR A SOUTH DOWNS FLOCK (PLATE LXXXVII). *Left is a study of a shepherd used in the picture illustrated in Plate LXXXVII.*

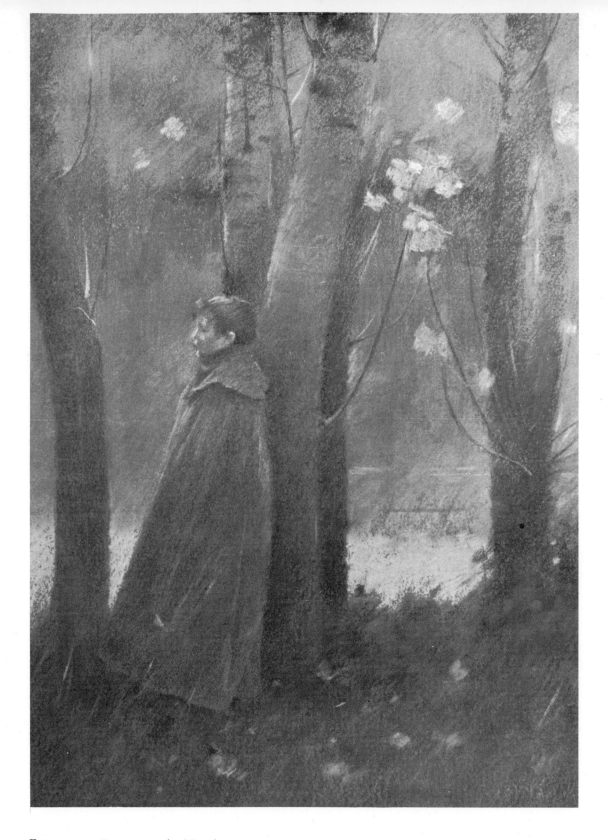

FIGURE IN A LANDSCAPE by Theodore Robinson (1852-1896), pastel on paper, 21″ x 15″. *The artist has visualized this very sparse, vertical composition as a series of flat and graded tones, seen mainly in silhouette. Observe how the trees are rendered as vertical strips of tone, varying slightly in their lightness or darkness so that some move forward in space and others drop back. The figure is also a flat patch of color, with touches of light and shadow picked up at critical points, like the edge of light on the face and on the tip of the ear, or the edge of shadow underneath the collar. The strokes tend to blend into one another and into the undertone of the paper itself, with individual strokes standing on their own only when crisp accents are needed. (Photograph courtesy Bernard Danenberg Galleries, Inc., New York.)*

6

LANDSCAPE: TECHNIQUE

The two charcoal drawings in Plates LI and LII represent a compositional analysis of the pastel landscape in Plate LIV. In Plate LII, the pattern of the landscape is clearly demonstrated. This result was arrived at by deliberately emphasizing the design as well as by a decisive rendering of contrasting light and shadow, so that no doubt is left as to the general principles relating to the structure of the finished picture.

HILLS

In the first stage of the pastel subject of *The Quantock Hills* (Plate LIII), which was done on dark gray paper, the outlines were made with soft charcoal; the ground colors of the sky were then put in with light and dark yellow ochre, followed in places with a coat of light gray.

The dark shadow colors of the distant hills consist mostly of deep ultramarine blue and purple. These, and all the other first-stage colors, were delicately handled so as not to lose the decided tone of the dark gray paper below. The distant wood rising to the crest of the hill was made with ivory black, burnt umber, and deep ultramarine blue, while the color of the nearer trees consists of ivory black and burnt umber only. The effect of light on the left side of the trees nestling in the valley was obtained with russet green. The same

LANDSCAPE by John H. Twachtman (1853-1902), pastel on paper. *Here is a remarkable example of how few strokes one needs to paint a landscape in pastel. Except for a few tiny strokes in the center of the picture, to indicate the delicate tracery of trees, the entire picture consists of carefully placed smudges of light chalk, middle tones, and a few darks. The cluster of trees to the left, for example, is rendered in just two tones: a blur of middle tones with a few dashes of darks to indicate slightly more precise forms. A few more touches of dark indicate foliage in the middle foreground, while a few touches of middle tones suggest the landscape receding to the horizon. Above the horizon are a few strokes of light to indicate clouds. But the dominant tone of the picture is that of the paper itself, which the artist has used brilliantly, with a handful of chalks, to create distance and atmosphere. (Metropolitan Museum of Art, New York, Rogers Fund.)*

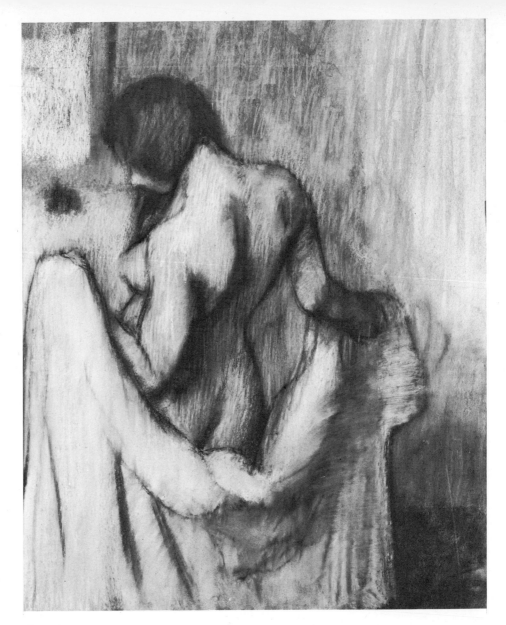

△

WOMAN WITH TOWEL—BACK VIEW by Edgar Degas (1934-1917), pastel on paper, 37¾" x 30". *Although Degas most often chose to follow the shape of the form when he applied his strokes, he allowed himself great leeway in deciding precisely how those strokes might follow the form. In this case, he surprises the viewer by applying strokes that follow the model's torso from top to bottom, much as the lines on a globe move from the north pole to the south pole. In other paintings, he may move his strokes around the form from right to left, as the equator moves around the globe. Not only has the artist minimized detail—as in the face without features or in the patch of color for the hair—he has actually smeared away detail and left the telltale smears for the viewer to see. (Metropolitan Museum of Art, H. O. Havemeyer Collection.)*

TWO DANCERS by Edgar Degas (1834-1917), pastel on paper, 28" x 21⅜". *The great-▷ est of all painters in pastel, Degas experimented with an incredible variety of strokes and combinations of strokes to render form, light, and texture. The length, direction, shape, and density of each stroke—and its relationship to the strokes beside it and beneath it—were studied with great care. Observe how the strokes of the skirt radiate from the dancer's waist to emphasize the crisp, flaring form. The strokes that interpret the floor are long horizontals and faintly diagonal marks, again following the direction of the form. On the faces, shoulders, and arms of the dancers, the light falls from above and is rendered in short, choppy, thick strokes which travel in the direction of the light and wrap themselves around the shapes from top to bottom. Behind the dancers, the strokes on the stage scenery take a different form: short, curving, irregular, scribbly marks melting into space. (Art Institute of Chicago, Amy McCormick Memorial Collection.)*

russet green was also used for the sunlit portion of the hills, aided by a few additional touches of light gray, which further emphasized the feeling of sunlight.

The warm tone of the foreground was made with burnt sienna. The dark gray paper represents the color of the stones or rocks at the foot of the picture towards the left side.

It is always important to remember that for the first stage of any landscape or figure subject the pastels chosen for use should be sparingly applied to the surface of the paper, so that the final pastel touches can be rendered without any technical difficulty.

With regard to the sky in the finished picture of *The Quantock Hills* (Plate LIV), cerulean blue was worked into the yellow ground tint. White and light yellow ochre did service for the clouds on the left side. Hooker's green and russet green blended well with the preparatory first-stage colors seen along the sides of the hills, while lemon yellow and light grass green helped to get the sunlight colors on the brightest portions. Light and dark burnt sienna as well as light and dark purple were used in other parts of the picture.

CLOUDS

Plate LVII represents a watercolor sketch which failed to represent clouds convincingly. To cover this failure, pastel was used and worked over the surface of the watercolor, with the result seen in Plate LVIII, which bears a strong testimony to the excellence of pastels as a medium for getting definite information in outdoor studies. The watercolor was painted on David Cox paper, the surface texture of which makes admirable ground for pastel treatment. Another watercolor paper—canvas-grained—which is quite suitable for pastel work, is described in the caption for Plate XII.

In Plate LV, the leading lines in the sky denote approximately the position of the numerous clouds. Plate LVI suggests the composition as well as the effect of the light clouds contrasting with a dark background.

The colors used for the finished pastel study were gradated cerulean blue for the sky and white, yellow ochre, with cool and warm gray for the clouds, in light and shadow. The colors of the landscape below can be clearly seen in the reproduction.

TREES AND
WATER

The Thames, near Maidenhead (Plate LXII) makes an excellent upright composition chiefly owing to the stately height of the trees towering up on the left side of the picture. The continuity of line relating to these trees makes a rather unusual shape, as seen in Plate LIX. The pathway in the foreground on the left assists in bringing the eye towards the river in the middle distance. In Plate LX, the pattern of the subject was severely adhered to by leaving out the clouds, thus giving greater value to the sparkling light on the river and the dark silhouette of the foreground trees.

In the pastel of the same subject, two shades of yellow ochre only were used in the first stage for the sky and river. The trees received more ivory black and burnt sienna than is depicted in the reproduction of the first stage, before introducing the final touches of green, etc. Light and dark gray, light Prussian blue, and yellow ochre proved to be very valuable colors for the sky in Plate LXII. Similar colors were used for the river. Prussian green and deep Hooker's green were laid over the first-stage colors of the tall trees on the left, with grays and yellows for the trunks and branches. The other tints—burnt sienna, russet green, and lemon yellow—were helpful for the trees on the right as well as for the foreground.

SEASHORE

Le Portal, Pas-de-Calais (Plate LXV) was done in one sitting outdoors. The rapidity with which pastel can be handled gives great assistance to the artist in conveying the atmosphere of any place or subject.

The limited time in which this sketch had to be done turned out to be a blessing. For instance, the row of houses spreading across the top of the hill was treated very simply in tone and showing only a little detail, whereas had more time been available the tendency would have been to show too much detail, thus losing to a certain extent the main theme of the subject.

The dotted lines in Plate LXIII suggest various converging lines caused by the arrangement of bathing tents and figures grouped along the beach. The other curves denote the positions of the foreground and middle distance. Plate LXIV gives a clear effect of light *versus* shadow. The dark-toned foreground, rising from the left to the top of the picture on the right, makes an excellent foundation—or support—to the lighter-toned material behind.

STROLLERS REST by Robert Henri (1865-1929) pastel on paper. *The colors are applied flatly, in broad strokes which tend to be thick and opaque. However, one patch of color continually breaks into and across another so that there is a constant interplay. The trees in the background are particularly interesting because the artist appears to have worked from dark to light; against the light sky, he has blocked in his darkest tones, over which have gone the middle tones, into which he has finally dashed the touches of light that break through the foliage. The painting has the intensity and directness of a rapid watercolor or oil sketch done on the spot—as this pastel was probably done. (Collection Mr. and Mrs. Raymond J. Horowitz.)*

Enough explanations have already been given of the compositional aspects of the *Le Portal* picture in Plates LXIII and LXIV to show how the drawing and design of the pastel painting depicted in Plate LXV were made.

The various colors involved in the making of the picture are clearly recognizable in the reproduction, always remembering that it is a safe device to lay on the dark colors first and the light colors last. In pastel technique the placing of light-colored pastels over a ground tint of deep-colored pastels will make an interesting, as well as a convincing, tone.

MOUNTAINS

In the charcoal drawing of *The Dolomites* (Plate LXVII) it does not, at first glance, seem possible that a series of flowing curves could connect up the various mountain peaks shown in the picture, but the analysis of line in Plate LXVI demonstrates how it is done. Plate LXVIII, which represents the finished picture of *The Dolomites,* was the result of several experimental color studies both outdoors and in the studio. Silver grays and warm yellows were much in demand when handling the pastels in the higher portions of the mountains. Farther down, gray was blended over orange chrome and burnt sienna. The deeper—or shadow—colors are ivory black, dark gray, and burnt sienna. Most of the sky was done with untramarine blue over light yellow ochre and light gray.

△
SIR JOHN READE by Rosalba Carriera (1675-1757), pastel on paper, 22¾″ x 18¼″. *One of the early masters of pastel was the Venetian painter Rosalba Carriera. Her method, and that of many early pastellists, was to conceal the stroke of the chalk by blending, and thus to give something like the effect of an oil painting. Notice the extremely subtle gradations of tone in the face and in the hair, with barely a trace of individual strokes. The artist's treatment of edges and transitions is particularly interesting: the hair fuses softly into the skin and blends just as softly into the dark background; nor are there any sharp edges within the features themselves, all of which melt into the surrounding flesh. (National Gallery of Art, Washington, D. C., Samuel H. Kress Collection.)*

MAN PLAYING CARDS by Lawrence Carmichael Earl (1845-1921), pastel on paper, ▷ 25″ x 17″. *One of the distinct advantages of pastel is that the paper can do your "blending" for you. Using a fairly rough paper with a distinct tooth, the artist has applied his color in such a way that the texture of the paper constantly breaks up the stroke and forces one stroke to merge with the next. Although the artist has done a certain amount of blending with the tip of the finger or perhaps with a stomp, most of the gradation is accomplished by allowing the chalk to ride along the ridges of the painting surface. (Photograph courtesy Ira Spanierman, Inc., New York.)*

7

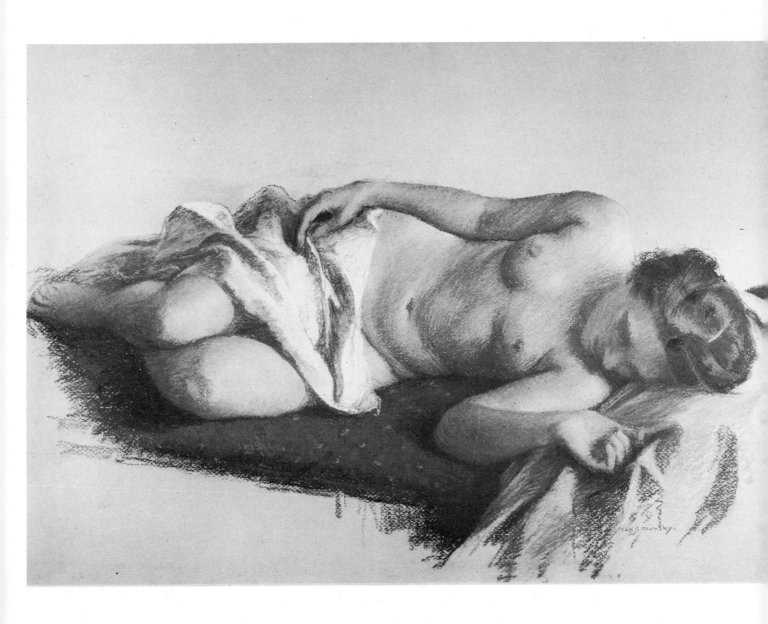

FIGURE

Maurice Quentin de la Tour, the famous eighteenth century French artist has more than amply verified the special value of pastel for portraiture. The accomplished ease and rapidity in which he handled this medium helped him to get a spontaneous—instead of a stilted—expression of his sitters. The lack of self-consciousness in his pastel portraits enabled him to give the personality—rather than the surface veneer—of his models.

THE PORTRAIT

The charcoal line drawing in Plate LXIX shows the general setting of the figure in relation to the size of the paper on which it is placed. It is drawn in the same proportion as the original pastel in Plate LXXII. In Plate LXX, a certain amount of tone has been added by rubbing in the charcoal, followed by touches of white chalk, so as to convey the position or locality of the highlights on the face and costume. The touches of white chalk make a valuable reference in case of lighting difficulties, during the painting of the portrait.

Referring to Plate LXXI, there are two color demonstrations on the right at the foot of the picture. They consist of light and medium burnt sienna. Only these two colors were used for the face of the portrait above, with the exception of the mouth.

MODEL RESTING by Ivan G. Olinsky (1878-1962), pastel on paper, 18″ x 26″. *In figure paintings in pastel, the effect of a vignette is often very effective, as in this study of a reclining nude. Although the figure is painted with great care, the picture gains a feeling of lively informality by fading away at the edges, where the drapery, the couch, and the shadow beneath the seat simply shade off into the bare paper. The artist has carefully avoided overworking his passages, even though he frequently resorts to blending; many of the strokes on the torso remain intact and unblended, while the edges of the drapery are simply indicated by a few rough strokes and patches of tone. Observe how the strokes on the torso increase the effect of roundness by taking their cue from the forms themselves, by moving around them, almost like contour lines on a map. (Photograph courtesy Grand Central Art Galleries, New York.)*

△

PORTRAIT OF DAWN by Jack Callahan, pastel on paper. *Traditionally, pastel is regarded as the ideal medium for portraits of children. This is obviously true because of the delicate, peach-fuzz quality of children's color, which is matched so perfectly by the unique surface quality of pastel chalks. In painting a child's head like this one, the temptation is always to over-blend with the fingertip in order to catch the evanescent tones of children's flesh. Although a certain amount of blending is likely to be necessary, the artist has wisely kept this technique to a reasonable minimum, applying his strokes lightly, blending them with just a touch, and frequently allowing the texture of the paper to break through, particularly in the shadow. The texture of the paper constantly enlivens his stroke and prevents the blending from becoming smooth and lifeless. To offset the blended effect in the face, the artist has applied his strokes far more roughly in the rest of the picture, with just a touch of blending the highlights in the hair; the broad strokes of the hair and sweater have not been touched. (Photograph courtesy* American Artist.)

◁MARIA by Marion Sharpe, pastel on paper. *This is an interesting example of knowing just how far to carry each part of a pastel portrait. The face is carefully built up to completion, with the exception of the ears, which are mere patches of tone and therefore melt back into the hair. The right hand, again, is carried far, while the left hand, which tapers out of the picture, is hardly indicated. The sweater is a fairly flat patch of color, enlivened by the texture of the paper which breaks through in tiny points of light and enriches the visual effect without becoming distracting. The left elbow disappears out of the picture and that arm is left unfinished in order to avoid creating a pointed shape which might carry the viewer's attention away from the center of interest. The background is mostly bare paper, except for a few notes of shadowy tone which frame the head. (Photograph courtesy Portraits, Inc., New York.)*

PAUL JULEY by Daniel Greene, pastel on paper. *A pastel head is often done as a vignette in order to give maximum attention to the head and thus minimize all extraneous detail. Here the head is carefully placed off center on the sheet and the clothing is merely indicated by a few rough, broad strokes which provide a pedestal, as it were, for the face which is the focal point of the picture. The tones of the head are built up in strong, forthright strokes which look very much like brushstrokes in an oil painting. Each stroke has its own distinct identity and is only faintly blended into the adjacent strokes. No stroke is allowed to blur out completely and lose its vigor. The hair has been carefully simplified into patches of light and shade, with just a few stray hairs picked out with light strokes in order to suggest more detail than is actually there. The dark underlying tone of the paper lends luminosity, by contrast, to the light flesh tones that are applied over it. (Photograph courtesy Portraits, Inc., New York.)*

DINGHA by Harvey Dinnerstein, pastel on board, 30″ x 22″. *Except for the very richly ▷ modeled head, this portrait is roughly painted in broad, flat, and broken tones. The head is built up in a series of small, individual strokes which overlap and interlock, but remain distinct; they are not smudged and blended as one might expect. Thus, the face retains the vitality of the artist's "handwriting." The background, on the contrary, consists of broad, extremely rough strokes of light chalk laid over a darker background; the effect is almost that of an impasto in an oil painting. The sitter's dark jacket is rendered in two tones; one for the over-all color and another for the darker fold.(Collection Dr. Herbert Simons, photo courtesy Kenmore Galleries, Philadelphia.)*

128

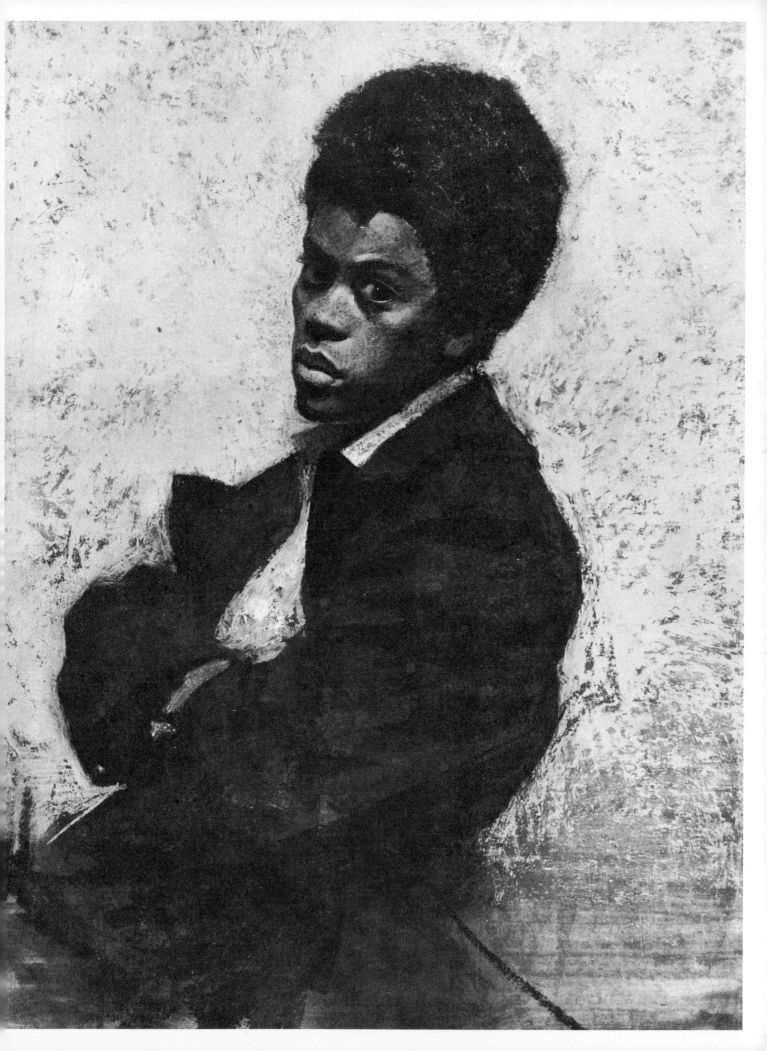

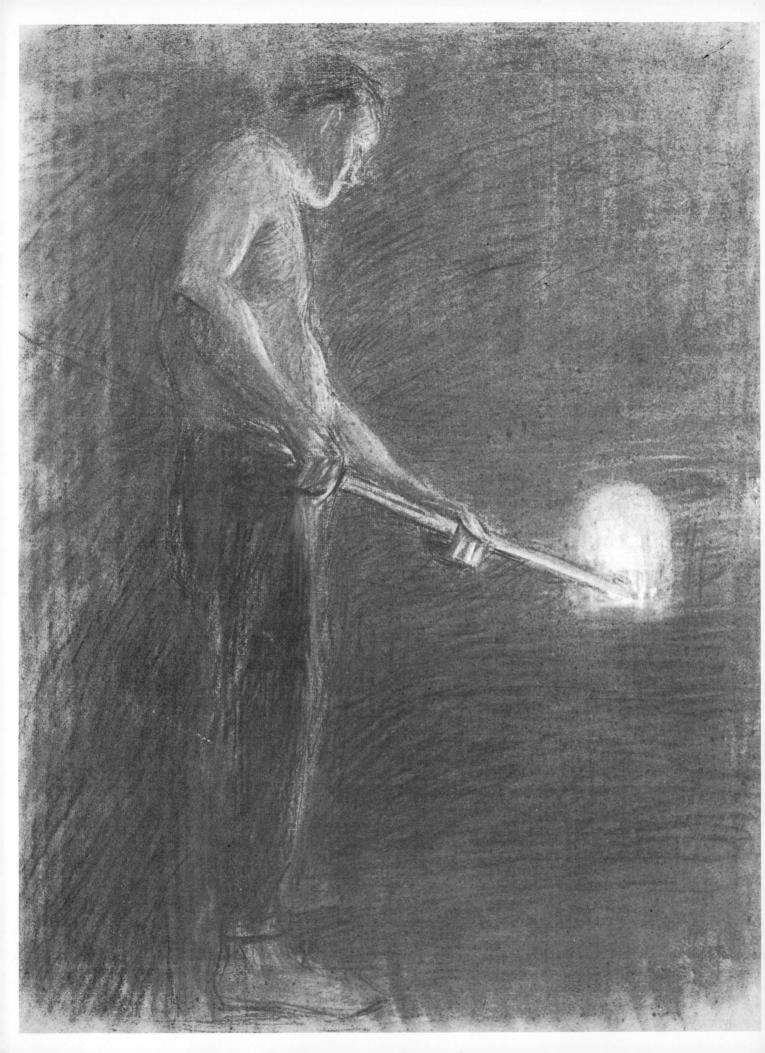

A correct foundation of light and shadow combined with color is vastly important in the first stage. The burnt sienna colors are helped very considerably by the neutralizing and cooling effect of the dark gray paper below.

Ivory black was used for the massing of hair, but the gray paper also assisted in giving atmosphere to the black pastel. Scarlet crimson pastel lightly applied suggested the tonality of the costume, and light gray with a blending of yellow ochre was used for the material around the neck.

Simplicity in the first stage should always be sought for if a successful finish is required.

It is not difficult to finish a portrait in pastel if the preliminary drawing has been correctly defined. In the *Portrait of Mrs. T. R. Badger* no drastic alterations were required after the burnt sienna ground had been laid on, so that the final touches offered but little difficulty.

The highest lights on the face were made with yellow ochre and light, cool gray blended of course into the burnt sienna color below. A mixture of light red and carmine was very delicately blended on the cheek.

The shadow situated about the eye and also on the forehead was originally made by rubbing in a flat tone of charcoal, followed by tentative touches of burnt sienna, which was also rubbed into the charcoal shadow.

The darkest portions of the eye and eyebrow were done with a brownish black pastel but great care had to be exercised, otherwise the strength of the pastel would have destroyed the serenity of the general tone around the eye.

Gray pastel sufficed to give a quiet effect of light on the dark hair. More light gray and yellow ochre were put on the collar of the costume. The scarlet crimson below was solidified by additional pastel touches, and lightly applied ivory black gave a suggestion of shadow on the right-hand side of the costume.

Yellow ochre, light red, middle and light gray were applied to the background with plenty of soft blending effects.

MAN AT THE FORGE by Aaron Harry Gorson (1872-1933), pastel on paper, 24½″ x 19″. *The pastel medium is particularly suited to rendering complex effects of light and shade, as in this painting of the side lit figure of a man at a glowing forge. The darkness, like the light, retains its luminosity because the artist has allowed his strokes to remain intact, with distinct spaces shining between them, giving an effect of vibrancy rather than dead blackness. The lighted edge of the figure is picked up with a minimum number of lighter strokes that do not follow the form precisely, but blur into the shadow side of the figure and into the dark background. Thus, the artist avoids the risk that the figure will appear like a paper cutout, light against dark; instead, he remains part of the atmosphere of the painting. The figure just barely emerges from the darkness, much of its outline obscured. (Photograph courtesy Ira Spanierman, Inc., New York.)*

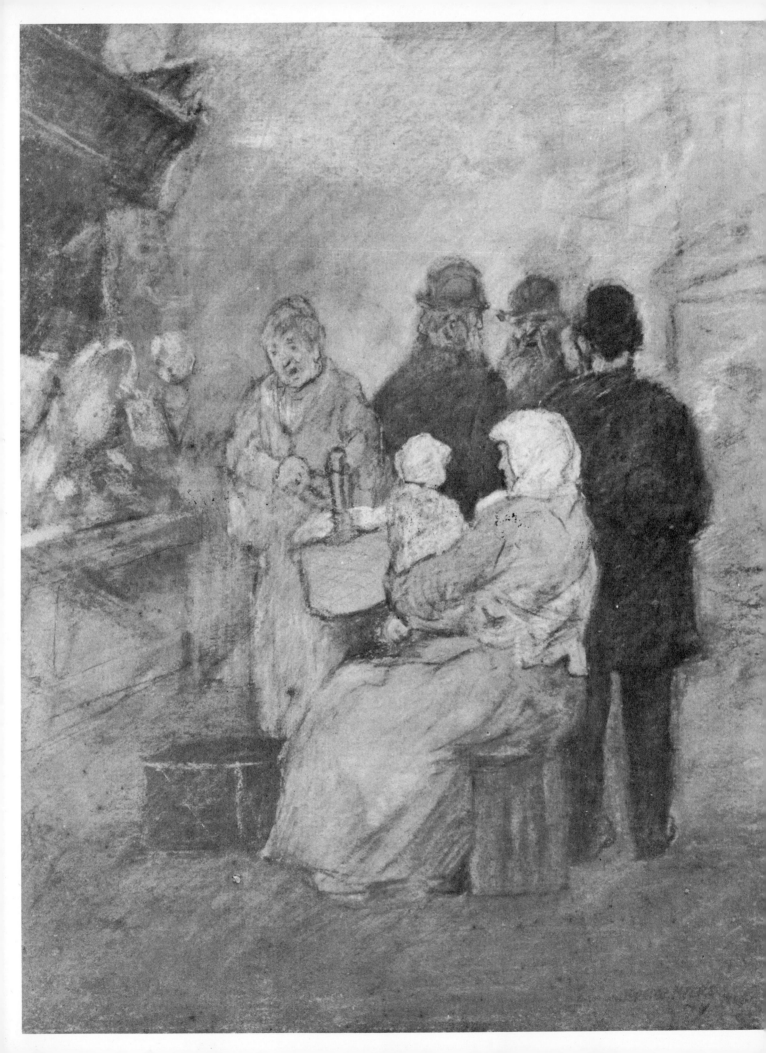

Plate LXXV shows the first stage of a market scene. The subject was chosen because of the groups of figures in the foreground, all of which were done out-doors from actual people moving about the market place.

The simple planning of the subject should be self-explanatory in the char-coal and chalk drawings in Plate LXXIV. The analytical drawing shown in Plate LXXIII is somewhat unusual when judged from the conventional stan-dards of pictorial composition.

Ivory black, dark brown, and reddish brown were strongly applied to the foreground figures in the first stage. Deep purple was useful for the tone of the roofs on the central building, the other buildings on the extreme left side, etc. The caption for Plate LXXV gives further information on the pastel treatment for the preliminary stage.

In the finished sketch (Plate LXXVI) all the buildings, figures, flags, etc., were strengthened in light and shadow with additional pastel touches. The result shows some vivid contrasts and pronounced color effects.

PEDDLERS ON LOWER EAST SIDE by Jerome Myers (1867-1940), pastel on paper. *Figures in a crowded city street are difficult to paint in oil or watercolor, particularly if the artist wishes to catch the details of faces and clothing. But the speed of pastel permits one to record these impressions rapidly and completely, as in this study of six figures in the immigrant quarter of old New York. The seated woman, holding the baby, is carefully placed in silhouette against the dark, standing figures of the three men. These darks are balanced by the dark basket in the left foreground and the note of dark in the storefront. (Collection Mr. and Mrs. Raymond J. Horowitz.)*

8

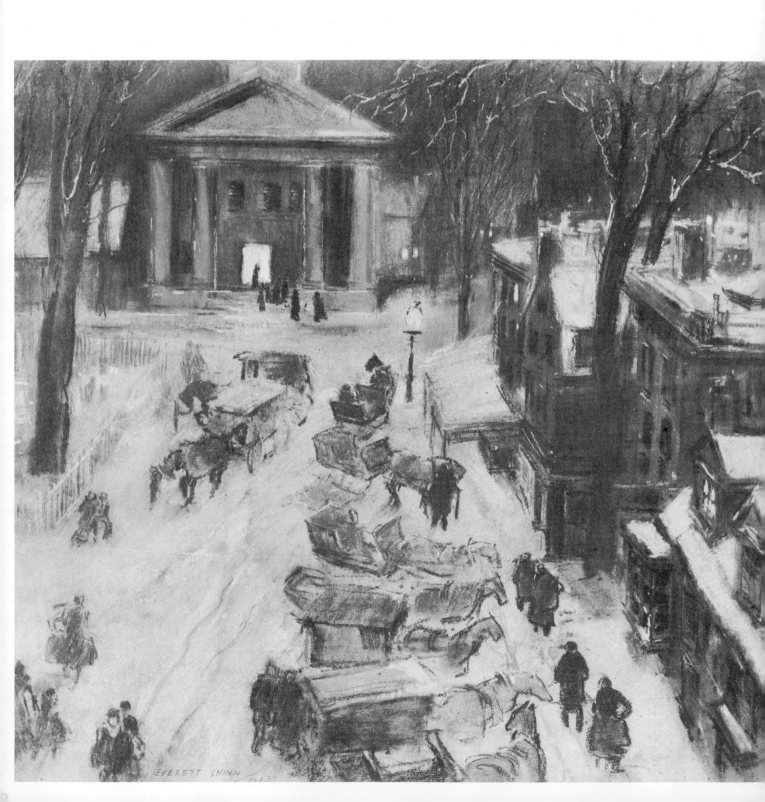

ANIMALS IN LANDSCAPE

To be able to draw and paint animals, and to use them as prominent features in pictorial compositions, is a rare accomplishment involving deep study and long experience. But when, as is usually the case, animals are painted in landscape as incidental features, an exact knowledge of structure is not generally regarded as absolutely necessary. If it were, the same claim could be made for the complete acquaintance with the botany of many trees, the place of every rope in ships, and a detailed knowledge of several styles of architecture. It might be better if all landscape painters had acquired such knowledge, but most readers will probably be among those who wish to give additional touches of life and interest to their pictures without becoming specialists in the anatomy of the cow and the sheep. For treatment in this manner, suggestions are here offered for sketching, grouping, and incorporating animals into suitable landscapes.

**METHODS OF
STUDYING
ANIMALS**

Any one who has attempted to draw animals outdors, following them in the fields and making swift notes of movement, has found that a great deal of knowledge and experience is necessary before a grazing cow can be sketched

CHRISTMAS EVE by Everett Shinn (1876-1953), pastel on paper, 16½″ x 19″. *Pastel lends itself best not to precise, linear drawing, but to blocking in broad color and tonal areas. It is valuable to study how the artist has handled the figures here; they are handled as flat silhouettes with an occasional linear accent or an occasional touch to indicate a hat, an arm, or a leg. In the same way, the horses are first blocked in as a flat tone, then touched with light and dark lines to indicate a bridle, a blanket, or an edge of light. The buildings, too, are rendered in flat tones which are then overlaid with additional strokes to indicate windows, chimneys, etc. Particularly interesting are the delicate, flickering strokes of light on the branches of the trees in the upper right-hand corner, and similar light strokes to indicate highlights on the snow, on the sleds, and on the columns of the church in the distance. (Photograph courtesy* American Artist.*)*

with tolerable accuracy. A successful sketch made under such circumstances is largely a composite of memories of previous studies with a few fresh facts added as the result of the new experience. To begin the study of animals in this way would be of little service. The non-specialist needs to take advantage of every other opportunity of gaining assistance. Good casts and even photographs can be useful, if used with intelligence and reserve. The knowledge gained, for example, by drawing a cast of a cow in several positions and memorizing each drawing would greatly facilitate the sketching of an actual cow in the same position. But no artificial aids should take the place of original sketches.

The cow and the sheep are the two most useful animals to the landscape painter. The varied warm colors of cows—reds, brown, black, gray, and white—emphasize and clarify the greens of any landscape. Sheep, especially when in groups, light up the picture with pale warm touches, and can be made to take an important part in the composition.

The method of study advocated is illustrated in Plates LXXVII to LXXXVII. Studies of cows and sheep are shown in stages of drawing and painting, with suggestions for their application to landscape.

ANIMALS IN A GROUP

A South Downs Flock (Plate LXXXVII) is an example of the summary treatment of the separate sheep necessary in the painting of a large flock. The outstanding characteristics of the animal and the variety of positions are emphasized, but the treatment is deliberately lacking in detailed finish so as to perceive the sense of the whole mass.

This picture was painted on a rather pale, warm gray paper, and most of the surface shows through slightly. The method of painting is as follows:

(1) Paint an almost flat tone for the darker parts of the clouds and rub in lightly.

(2) Paint an almost flat tone for the sky and rub in considerably.

(3) Indicate the lights in the clouds and rub in lightly.

(4) Paint the grass roughly with a flat tone, leaving a good deal of paper showing through to modify the color. Do not rub in.

WOODLAND SCENE by Arthur B. Davies (1862-1928), pastel on paper. *The soft touches of the chalk are never allowed to overwhelm the underlying texture of the paper, which roughens and enlivens every mark. Observe how the shadow at the base of the nearest tree reveals the tooth of the paper. The blooms of the flowering trees are soft, but have not been smudged by the artist's hand; their softness is the result of the interaction of the chalk and the textured paper, which breaks up and blends the stroke. Thus, each touch of color seems to melt away into the paper itself and into the surrounding touches of color. Although the painting gives the impression of a complete landscape, it is actually a vignette, with nearly all precise detail clustered in the center, while the rest of the composition melts away at the edges and the corners are left virtually blank. (Collection Mr. and Mrs. Raymond J. Horowitz.)*

△
INTERLUDE by Everett Shinn (1876-1953), pastel on canvas, 20″ x 20″. *It takes an extremely powerful, decisive stroke to paint a pastel on canvas, whose weave is inclined to intrude upon the texture of the chalk. In this very bold study of a dancer adjusting her slipper, the artist has put the texture of the canvas to work for him in the shadow area beneath the figure, where he wants the weave to enliven his tone. The slashing strokes of white chalk are applied heavily and unhesitatingly to overwhelm the texture of the canvas. The only evidence of blending is in the face, neck, and chest, where the artist wanted an effect of shadow which contains reflected light. (Photograph courtesy Bernard Danenberg Galleries, Inc., New York.)*

STUDY FOR COMPOSITION by Robert Brackman, pastel on paper. *This study of three▷ figures is interesting because it demonstrates how pastel can be used both as a painting medium and as a drawing medium—and in the same picture. The figure in the foreground is a complete pastel painting in a full range of tone and color; the figure in the middle distance (in the upper right-hand corner) is not carried quite so far in the development of tones or color and there is much more reliance on the drawn line; while the background figure (in the upper left) is essentially a drawing in line with touches of tone. The effect is not only to direct the viewer's attention to the central figure in the foreground, but also to place each of the three figures in its own spatial plane, one behind the other. However, despite the very advanced state of completeness in the foreground figure, observe how the drapery fades away into a rough drawing once again, thus not distracting the eye from the figure itself. (Photograph courtesy the artist.)*

(5) Paint a flat tone of warm gray over the distance and the part of the flock in shadow, then a warm brown flat tone over the part of the flock in strong light. Rub in lightly.

(6) Paint the flat undertones of the shadow at the bottom of the picture, the sheep in the foreground, and the figure.

(7) If the relative tones are not correct make the necessary alterations, and then modify the flatness of the tones where required. All the undertones must be exactly right before the finishing touches are commenced. This is the most critical point in the painting of the picture. There is always a tendency, with the inexperienced, to make the undertones too dark. The finishing touches should be applied with strong, swift, certain strokes to give a sense of conviction. None of these strokes should be rubbed in. In painting the sky, use the side of short pieces of pastel in preference to the point. In the rest of the picture the point is preferable. The most emphatic touches should be in the extreme foreground.

SUGGESTED READING

Degas Pastels, by Alfred Werner, Watson-Guptill, New York

Landscape Painting Step-by-Step, by Leonard Richmond, Watson-Guptill, New York

Painting Outdoors by Ralph Fabri, Watson-Guptill, New York

Painting Cityscapes, by Ralph Fabri, Watson-Guptill, New York

Pastel Painting: Modern Techniques, by S. Csoka, Reinhold, New York

Pastel Painting Step-by-Step, by Elinor Lathrop Sears, Watson-Guptill, New York

Pastels for Beginners, by E. Savage, Watson-Guptill, New York

INDEX

Abbey, demonstrated, 78-79

Animals, 135-140; anatomy of, 135; in a group, 136, 140; methods of studying, 135-136; painting technique for, 140; demonstrated, 107-112

Autumn, demonstrated, 82-83

Beach, demonstrated, 99-100; see also Seashore

Begonias, 31-33; demonstrated, 67-68; see also Flowers

Blending, illus., 51, 122-127; see also Technique

Brackman, Robert, illus. by, 14, 139

Bridges, demonstrated, 76-77

Buildings, demonstrated, 78-79

Callahan, Jack, illus. by, 127

Canvas, painting on, illus., 138

Carriera, Rosalba, illus. by, 122

Cassatt, Mary, illus. by, 22-23

Chalks, colored, 11; for preliminary study, illus., 107, 108

Charcoal drawing, 58; 49-112 passim

Chase, William M., illus. by, 10, 36, 38

Children, illus., 127; see also Portraits

Clouds, 118; watercolor study of, 92; demonstrated, 91-93

Color, 11-16; and special needs, 16; and subject, 11-12; blending of, illus., 51; charts, 12-13; choosing, 12-16; for landscape, 45-47; for notes, 45; influence of paper on, 17-20, 50; number of, 16; of clouds, 118; of flowers, 31; of hills, 115; restricted, 47; schemes for landscape, 47; superimposed, 51

Color plates, 49-112

Composition, 65; 49-112 passim; still life, 29; upright, 119, 94-95

Cows, 136; demonstrated, 107-108; see also Animals

Cushions, demonstrated, 58-59; see also Still life

Dabo, Leon, illus. by, 32

Daffodils, 34-35; demonstrated, 69-70; see also Flowers

Daisies, demonstrated, 75; see also Flowers

Davies, Arthur B., illus. by, 137

Degas, Edgar, illus. by, 116, 117

Demonstrations, 49-112; of abbey, 78-79; of autumn, 82-83; of beach, 99-100; of begonias, 67-68; of bridge, 76-77; of clouds, 91; of cows, 107-108; of cushions, 58-59; of daffodils, 69-70; of daisies, 75; of figures, 112-113; of five colors, 53; of flowers, 67-75; of hills, 88-90; of jugs, 60-64; of landscape, 76-101; of lighting effects, 84-87; of marigolds, 71-72; of market scene, 104-106; of mountains, 80-81, 84-87, 99-100; of one color, 52; of pastel over watercolor, 55; of pastoral, 108-109; of portrait, 101-103; of river, 94-95; of seashore, 99-100; of sheep, 110-111; of silk, 57; of statuette, 65-66; of suggestiveness of pastel, 54; of three colors, 53; of tulips, 73-74; of two colors, 53; of velvet, 56

Dewing, Thomas, illus. by, 19

Dinnerstein, Harvey, illus. by, 15, 129

Direct method, illus., 51; see also Technique

Drawing, 58; 49-112 passim

Earl, Lawrence Carmichael, illus. by, 123

Figures, 125-133; grouped, 132-133; demonstrated, 112-113; illus., 116-117, 124, 130-131, 134, 138, 139; see also Nudes; Portraits

Fishburne, St. Julian, illus. by, 26

Fixative, and pastel paper, 17; see also Spray fixative

Flowers, 31-35; colors for, 31; pictorial groups of, 37-43; studies of, 31-35; demonstrated, 67-75; illus., 32, 42

Framing and hanging, 24

Gorson, Aaron Harry, illus. by, 130

Green, Daniel, illus. by, 128

Handling, 34

Hassam, Childe, illus. by, 30

Heads, illus., 128; see also Figures; Portraits

Henri, Robert, illus. by, 44, 120

Highlights, 132
Hills, 115-117; line analysis of, 88; demonstrated, 88-90; *see also* Mountains

Jugs, demonstrated, 60-64; *see also* Still life

Landscape, 115-123; animals in, 135-140; choice of subject, 48; color schemes for, 47; materials for, 45-48; sketches of, 45-49; sketching papers for, 47; techniques for, 118-121; demonstrated, 76-101
la Tour, Maurice Quentin de, 125
Laying-on, 20-21; *see also* Technique
Leaves, marigold, 37, 40; tulip, 41; *see also* Flowers
Levine, David, illus. by, 28
Light and shade, 131; 49-112 *passim*; illus., 130
Lighting effects, demonstrated, 84-87

Marigolds, 37-41; demonstrated, 71-72; *see also* Flowers
Market scene, demonstrated, 104-106; *see also* Figure; Landscape
Materials, 11-25; for landscape, 45-48; for sketching, 25
Matting, 24
Metcalf, W. L., illus. by, 46
Methods, 11-25
Mountains, 121; demonstrated, 80-81, 84-87, 99-100
Myers, Jerome, illus. by, 131

Nudes, illus., 38, 124; *see also* Figures; Portraits

Olinsky, Ivan G., illus. by, 124
Outdoor sketching, 25; *see also* Landscape

Paper, 16-21; and shadows, 47; and technique, 20-21; and texture, demonstrated, 56-57; brown, 20; fading of, 20; gray, 20; influence of color and tone of, 17-20; influence of on opposing colors, illus., 50; influence of surface, 16-17, 49; pastel, 17; red, 20; resiliency of, 17; sketching, 47; texture of, 17; untouched, 66; demonstrated, 49-112 *passim*
Pastel, compared with colored chalks, 11; composition of, 11; grades of, 111; laying-on of, 20-21; permanence of, 24; rubbing-in of, 21; *see also* Color; Technique

Pastoral, demonstrated, 108-109
Petals, 34-35; marigold, 40; tulip, 40-41; *see also* Flowers
Phillipp, Robert, illus. by, 33
Poppies, illus., 30; *see also* Flowers
Portraits, 125-132; demonstrated, 101-103; illus., 122-123, 126-127, 128; *see also* Figures; Nudes
Preservation, 24

Redon, Odilon, illus. by, 42
Rhythm, 65
Rivers, 119; demonstrated, 94-95; *see also* Water
Robinson, Theodore, illus. by, 113
Roses, illus., 36; *see also* Flowers
Rubbing-in, 21; demonstrated, 60-61, 49-112 *passim*

Seashore, 119-121; demonstrated, 99-100
Sharpe, Marion, illus. by, 126
Shadows, and paper, 47; in portraits, 132; demonstrated, 49-112 *passim*
Sheep, 136-140; demonstrated, 110-111; *see also* Animals
Shikler, Aaron, illus. by, 18
Shinn, Everett, illus. by, 134, 138
Silk, texture of demonstrated, 57
Sketching, materials for, 25
Spray fixative, 24
Statuettes, demonstrated, 65-66; *see also* Still life
Sterner, Albert, illus. by, 39
Still life, 27-29; composing, 29; demonstrated, 56-66

Technique, 49-113, *passim*; laying-on, 20-21; rubbing-in, 21; paper surface and, illus., 49
Texture, 15; of cushions, 58-59; of silk, 57; of velvet, 56; *see also* Paper
Trees, 119; *see also* Landscape
Tulips, 40-43; demonstrated, 73-74; *see also* Flowers
Twachtman, John H., illus. by, 114

Velvet, 56

Water, 119
Watercolor, as ground for pastel, 118; of study of clouds, 92; demonstrated, 55
Working indoors, 27-29
Woods, illus., 137; *see also* Landscape; Trees

Edited by Margit Malmstrom
Designed by James Craig and Robert Fillie
Composed in twelve point Garamond by Harry Sweetman Typesetting Corp.